IMAGES
of America

CONCORD

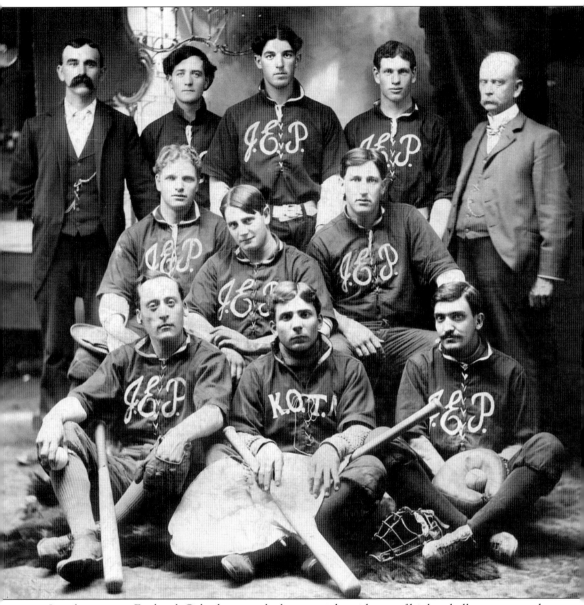

Local sports star Frederick Galindo sits at the bottom right with one of his baseball teams around 1900. (Courtesy of the Concord Historical Society.)

IMAGES
of America

CONCORD

Joel A. Harris

ARCADIA
PUBLISHING

Published by Arcadia Publishing
Charleston SC, Chicago IL, Portsmouth NH, San Francisco CA

Printed in the United States of America

Library of Congress Control Number: 2008942869

For all general information contact Arcadia Publishing at:
Telephone 843-853-2070
Fax 843-853-0044
E-mail sales@arcadiapublishing.com
For customer service and orders:
Toll-Free 1-888-313-2665

Visit us on the Internet at www.arcadiapublishing.com

*To my wife, Christy Munson-Harris,
who brought me to Concord and gave me the best reason to stay.*

CONTENTS

ACKNOWLEDGMENTS

This book would not have been possible without access to the extensive and well-organized collection of the Concord Historical Society, who provided most of the photographs used here. Many patient hours were spent by Janet Bruno, Beverly Ginochio, Lind Higgins, and Kay Massone helping me locate, identify, and research the photographs used in this book. Additional assistance and photographs were provided by Jerry Wentling, Stella Curletto, and the Contra Costa County Historical Society. The Concord Historical Society is located at 1601 Sutter Street, Suite F, in Concord and can be reached by mail at P.O. Box 404, Concord, CA 94522. Their phone number 925-827-3380, and they can be found online at www.conhistsoc.org. Please consider joining the society.

Every photograph in this book was expertly scanned, repaired, and enhanced by Leah Pels. This book, and the quality of its images, would have been impossible without her. Examples of her work and many fine products and images can be seen and purchased on her Web site, www.claudetteis.com.

The information about each photograph and the people, events, and places depicted came from a variety of sources, including the photographs themselves; the Concord Historical Society; *History of Concord, Its Progress and Promise* by Edna May Andrews, et al.; *Concord in the Town of Todos Santos* by the History of Concord Research Project; *Old Times in Contra Costa* by Robert Daras Tatam; *The History of Contra Costa County* by F. J. Hulaniski; *History of Contra Costa County* by Mae Fisher Purcell; and other sources. If you find any errors or discrepancies, please direct them to me at joelharris@aol.com or visit Clayton Books at 5433 D Clayton Road and let me know.

INTRODUCTION

Located about 30 miles east of San Francisco, California, the City of Concord is nestled between Mount Diablo to the east and the California Delta to the north. The city covers about 30 square miles and with 122,000 residents is the largest city in Contra Costa County.

Before the Spanish, Mexican, and later European and American settlers came to Concord, it was the home of one or more Native American tribes. Different sources place the Bolgone tribe, Chupacane or Chupcan tribe, and the Saklan and other tribes of Miwok Indians in prehistoric Concord. All sources agree that the Concord area tribes were primitive and lacked the art and culture of the eastern Native American tribes. They lived off of the plentiful herds of antelope, deer, and elk, streams filled with salmon, and fertile lands.

The Spanish explorers and settlers who arrived in the area met with some resistance from the local Native Americans, but many Native Americans did not survive smallpox epidemics in the 1830s. The surviving Native Americans were either converted in the missions or became servants and laborers on the ranchos. By the census of 1891, only four Native Americans were shown to live in all of Contra Costa County.

The first European explorers known to have reached the Concord area were Capt. Pedro Fages and Padre Juan Crespi out of Monterey in 1772. With 12 soldiers, a muleteer, and a Native American guide, they set out to find a land route to Point Reyes from Monterey. They traveled along the east bay shores through Martinez and climbed the hills at Willow Pass.

The Fages expedition of 1772 was soon followed by the de Anza expedition of 1775–1776 led by Lt. Col. Juan Bautista de Anza out of the Presidio of Tubac in Sonora. De Anza had previously opened an overland route to California in 1774. In 1775, the viceroy of New Spain authorized de Anza to lead an expedition and soldiers and their families to settle San Francisco. Lt. Jose Joaquin Moraga was second in command, and Friar Pedro Font, a Franciscan missionary who excelled at reading maps, was expedition chaplain.

Approximately 300 people with their animals and equipment survived the 80-day journey to San Francisco, which was officially founded by de Anza on March 28, 1776. Soldiers Juan Salvio Pacheco and Nicolas Galindo were part of the expedition. They were both garrisoned in the Presidio of San Francisco. Juan Salvio Pacheco had brought his family, including his son Ignacio Pacheco, and they later moved with him to Monterey. In 1793, Ignacio Pacheco had a son he named Salvio after his father.

The lands of Contra Costa were assigned in the Mexican land grants of the 1820s and 1830s. Don Miguel Pacheco was granted the Arroyo de las Nueces y Bolbones Land Grant, which included all of the Walnut Creek and Ygnacio Valley area. His nephew Don Salvio Pacheco was granted the adjacent Monte del Diablo Land Grant, which was bounded by Arroyo de las Nueces (Walnut Creek) on the south, Suisan Bay to the north, Clyde to the west, and Kirker Pass Road (Clayton) to the east.

The name "Monte del Diablo" or "Mount Diablo" has at least three different possible origins. It may have originated with Spanish soldiers, who were describing the dense thicket or *monte* of willow trees at the north end of the valley. This thicket was a Native American burial ground, which the Native Americans believed was haunted by their ancestors because at night they observed strange lights, probably fireflies. The soldiers believed the area was haunted by devilish Native American spirits, so the name "Monte del Diablo" or "thicket of the devil" was given to the area. Early American settlers may have translated the word *monte* to "mountain" and given the mountain the name "Mount Diablo."

Another story has the Spanish soldiers fighting the local Native Americans when a devilish-looking masked figure appeared among the Native Americans. Believing this to be the devil, the soldiers name the area "Monte del Diablo." A third origin of the name comes from the indigenous burning chaparral plants that grow on the mountain. The Native Americans called this plant the "devil plant" because it burned and scratched when touched.

Today Concord has a dynamic, high-rise business core, regional shopping centers, and a vibrant downtown area centered on Todos Santos Plaza. Concord is home to several important historic sites and 28 parks, including Mount Diablo State Park. But the real history of Concord begins with the founding and settling of Rancho Monte del Diablo by the Pacheco family.

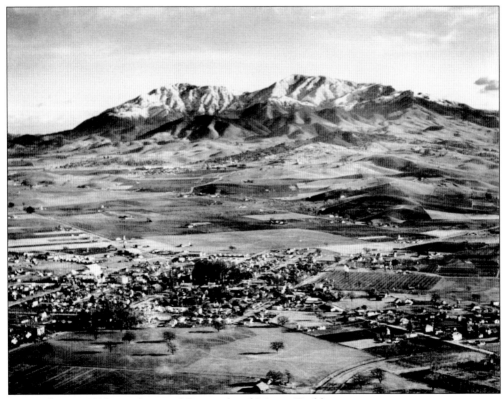

Pictured is a *c.* 1930 aerial view of Concord and Mount Diablo.

One

THE MEXICAN
LAND GRANT FAMILIES

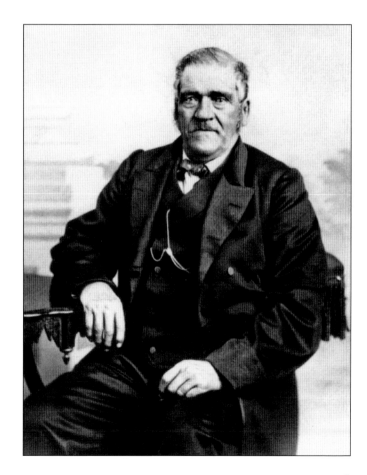

Salvio Pacheco grew up to become a soldier in the Monterey Company of the Mexican army and later a mission guard in San Jose. He retired from the military and became the *alcalde* of San Jose, acting as a combination mayor, police chief, and justice of the peace.

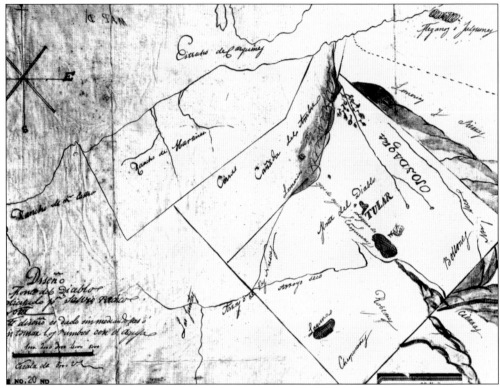

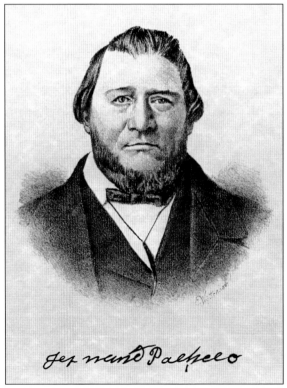

In 1827, Salvio Pacheco requested from the Mexican government sufficient land for "850 head of horned cattle, a flock of sheep, and three droves of mares of 30 head each." He was granted almost 18,000 acres of land in the Diablo Valley in 1828, which became the Rancho Monte del Diablo. The rancho was bounded by Walnut Creek on the south, which was then called Arroyo de las Nueces, and Suisan Bay to the north. It stretched west to Clyde and east to Kirker Pass Road and Clayton. This image is the original *diseño* for Rancho Monte del Diablo submitted by Salvio Pacheco to the Territorial Deputation Council in 1834.

Busy with his duties in San Jose, Salvio Pacheco sent his eldest son, Fernando Jose Maria Pacheco, to settle the land of Rancho Monte del Diablo. Born in 1818, Fernando was 17 when he was sent to settle the new rancho with a large herd of cattle.

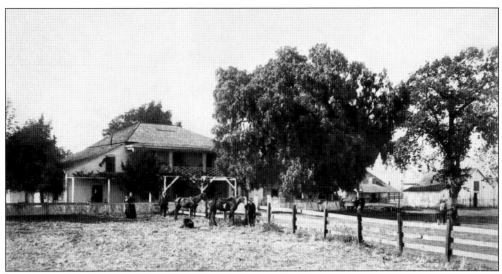

In the 1840s, Salvio Pacheco built the Pacheco Adobe, a two-story home with 12 rooms and a balcony, set beside artesian springs. It was located at the corner of Salvio and Adobe Streets and was constructed by the Miranda brothers of Sonora, Mexico. The adobe included a swimming pool, dance floor, and bullring. Salvio Pacheco moved into the adobe in 1846.

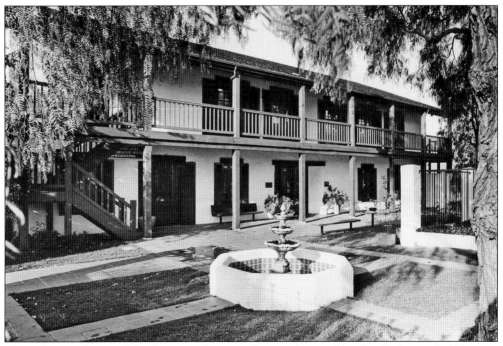

The Salvio Pacheco Adobe, home to the area's first resident and his family for nearly 100 years, is a California State Landmark. The adobe has been fully restored, as shown here.

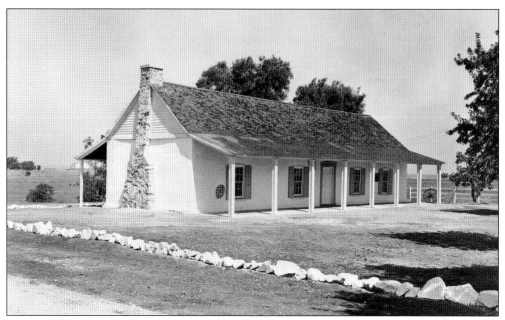

When Salvio Pacheco moved into the Pacheco Adobe, he gave his son Fernando Pacheco 1,000 acres on the north side of the rancho. In 1856, Fernando built his own home, the Fernando Pacheco Adobe, on Grant Street. Fernando was famous for his fiestas and become so fat that a special carriage was built to accommodate his exceptional girth. This picture shows the Fernando Pacheco Adobe as it was restored in 1945.

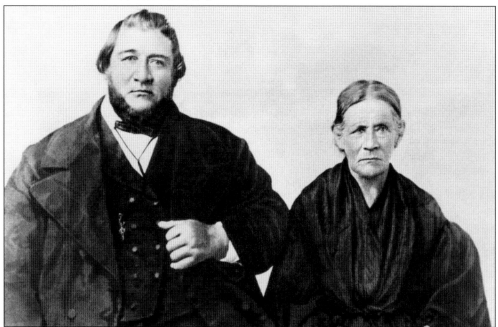

Fernando Pacheco is pictured here with his mother around 1865. Fernando was famous for his hospitality and great fiestas. By the time of his death in 1884, he weighed about 400 pounds. The Fernando Pacheco Adobe became a California State Landmark in 1958 and became the first building in Concord included in the National Register of Historic Places.

In 1850, Salvio Pacheco's daughter Manuela Pacheco married Francisco Galindo. Salvio gave them 1,000 acres on the south side of the rancho. Together Francisco Galindo and Salvio Pacheco founded the town of Todos Santos.

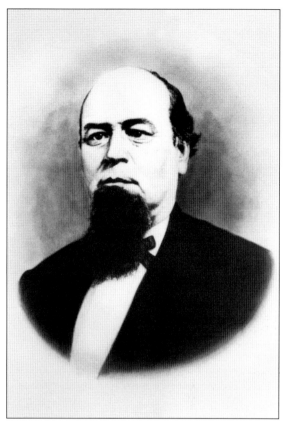

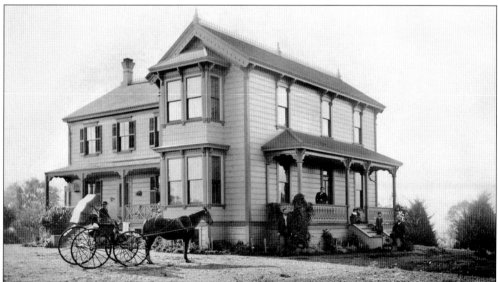

The home of Francisco Galindo was built in 1856 at 1721 Amador Avenue near Clayton Road. He raised cattle, sheep, and horses. Galindo later reduced the size of his herds and began growing wheat. He also kept a large herd of horses for parades and races. He later acquired an additional 4,000 acres, and his ranch spread from the city of Clayton to Cowell Road and up to the hills. The Galindo home was entered into the National Register of Historic Places on May 20, 1998.

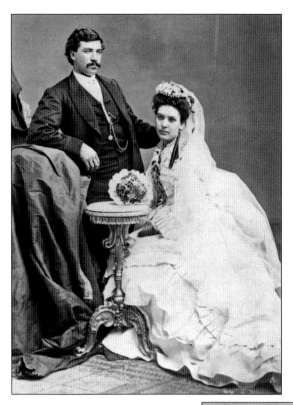

Juan Chrisostomo Galindo, eldest son of Concord founder Francisco Galindo, and Marina Amador Galindo, granddaughter of Salvio Pacheco, were married in Concord in 1873. The wedding was celebrated in Spanish fiesta style for several days, and most of the local population attended.

Francisco Pacheco's daughter Maria Assuncion Pacheco was born in 1858. She married Jose Julian Cantua, who was born in 1840 in Monterey, California. His father was Jose Julian Cantua y Castillo. His mother was Maria Isabel Ortega y Arce, who was born in 1797 at Mission Santa Barbara and was the granddaughter of Lt. Francisco Ortega.

Marina had lived in the Salvio Pacheco Adobe and later moved with Juan (John) to the Galindo house when he took over management of his father's ranches. Their four children were Frederick, Amelia, Sarah, and Victor. This picture of Juan was taken about 10 years after the wedding.

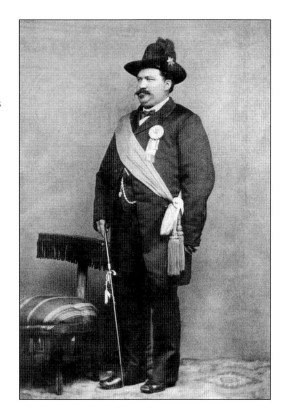

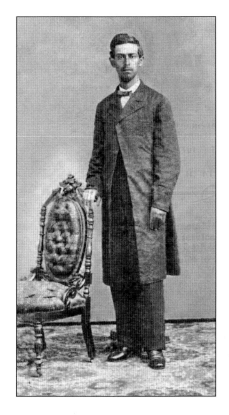

Born in Santa Clara, California, Jesus Maria Pacheco was the father of Charles Pacheco. Jesus ran the first stage line in Concord, which provided transportation from Oakland, Lafayette, Walnut Creek, and Pacheco, ending at Henry Ivey's livery stable in Concord.

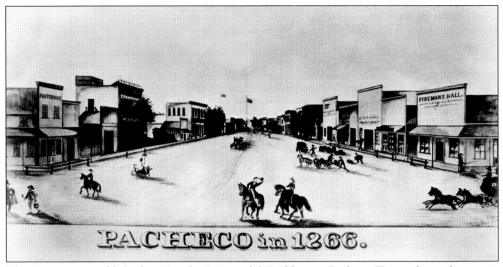

The first town established in Rancho Monte del Diablo was Pacheco Town, drawn here as it looked in 1866. Pacheco Town was located on a navigable creek on Salvio Pacheco's rancho. It was established as an inland port, and ships would sail up Grayson Creek to Pacheco to deliver cargo and load goods. Every year, floods would cover the town and deposit so much silt in the creek that it became too shallow for the ships to make the journey to town. The annual floods and numerous fires were a regular hazard to the merchants of Pacheco Town.

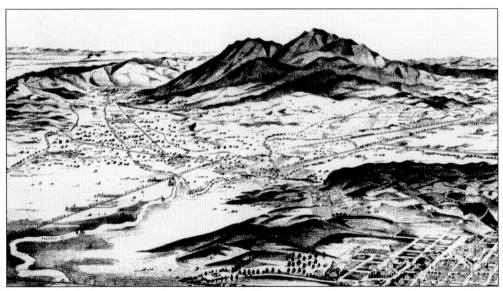

In 1876, Don Salvio Pacheco, his son Fernando Pacheco, and his son-in-law Francisco Galindo founded the town of Todos Santos or "all saints." The new town was the idea of Salvio Pacheco, who wished to relocate the now landlocked and flood-ravaged town of Pacheco to higher ground near his adobe.

16

Two

TODOS SANTOS BECOMES CONCORD

This 1894 picture shows Presentation Soto's daughters Florence and Elma Soto.

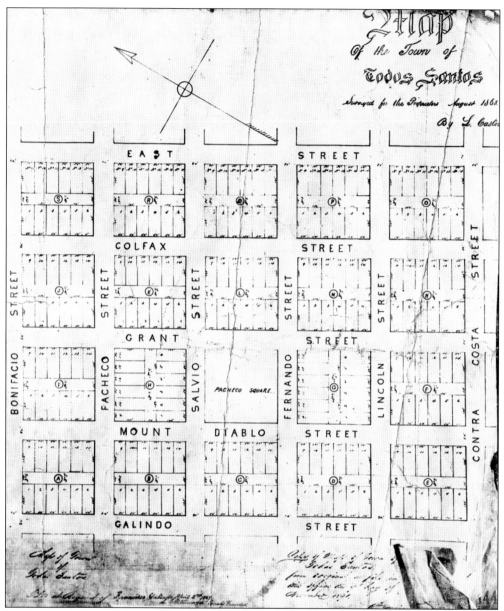

The Pachecos hired Alameda County surveyor Luis Castro to survey 20 acres for the new town. Nineteen blocks were plotted around a central plaza. Don Salvio Pacheco dedicated the plaza to the people of his new town to use as a park. Salvio Pacheco offered the merchants of Pacheco Town land around the plaza in Todos Santos for $1 if they would move their stores to Todos Santos. Some merchants accepted the offer, as well as the Pacheco Odd Fellow's Hall, which was moved to Todos Santos. The first merchant to accept Don Salvio's offer was Samuel S. Bacon, who moved his building from Pacheco to a lot near the new plaza. Bacon built his home next door.

THE NAME!—"CONCORD" isthe name, as we hear, by which the sponsors have decided to call the new village that is to form the east extension of Pacheco town. For significance and euphony no finer designation could have been found, and, in the spirit of the name, we congratulate our neighbors on its adoption.

The Spanish population and donors of the land for Concord named it Todos Santos, which translates to "all saints." Some Americans jokingly began calling the town "Drunken Indian" after the vagrant "Dan Empty," who, when not begging, was often found draped over the wooden sidewalks, dead drunk. The town's name was changed by an announcement the *Contra Costa Gazette* to "Concord" in this April 17, 1869, notice.

KNOW ALL MEN, AND IN PARTICULAR ALL WHOM IT MAY CONCERN: That the new town started to the East of Pacheco, in the Monte del Diablo Rancho and county of Contra Costa, has falsely acquired the name of *Concord*, and in reality its true name is "TODOS SANTOS," as may be seen in the County Record. Wherefore, all business men who have any business in said town, will please remember its name, and particularly in making Deeds or, any other land transactions—for in fact the town of "Concord" does not exist.
Sept. 22, 1869. 8

FERNANDO PACHECO

The Pacheco family did not agree with the name change and placed their own announcement in the *Contra Costa Gazette* on September 22, 1869, which was ignored by the residents of Concord, though for a time during this period the town was referred to in the *Gazette* as "Concord in the town of Todos Santos." The plaza in the center of town still bears the name Todos Santos.

Children are shown parading in Todos Santos Plaza in 1878. The children include, from left to right, Charles Klein, Mitch Neustaedter, Charles Pacheco, John Fisher, unidentified, William Gavin, Fred Klein, Gus Klein, two unidentified, Emanuel Souza, Alonzo Hernandes, and Joe Williams. The girl in front is unidentified.

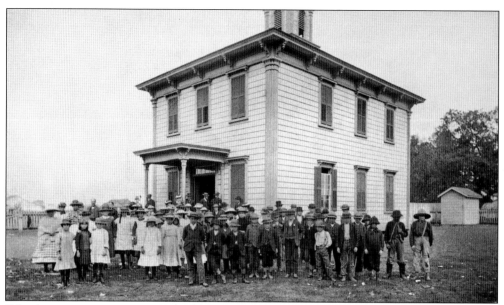

School was important even in rancho days. Soon after the new town was laid out, Concord Grammar School was completed in 1870. The school was built on land donated by Fernando Pacheco at the corner of Grant and Bonifacio Streets. It was larger than the one-room schoolhouses more typical of the time. The names of the students are unknown, but the first teacher was Annie Carpenter. This picture was taken in 1881.

Englishman Charles Boles, also known as Black Bart, was a teacher at Concord Grammar School from about 1874 to 1877. During these years, he robbed Wells Fargo stagecoaches in outlying counties around Northern California, wearing a flour sack over his head, carrying an unloaded shotgun, and leaving a verse at the scene of each crime. (Courtesy of Wells Fargo Bank and the Contra Costa County Historical Society.)

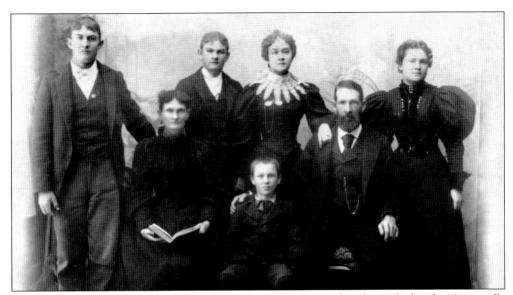

After the Civil War, John Wrigdon Guy moved to Contra Costa, where he worked in the Nortonville coal mines. He later moved to Concord, where he built the first firehouse and operated the first mortuary in town. John and his son Charles Henry Guy, who married Francisco Galindo's granddaughter Amelia Galindo, served as Concord postmasters. Charles Guy was the 10th mayor of Concord. Pictured from left to right are (first row) Forbes W. Guy, Lavenia Tennessee Guy, John Walter Guy, John Wrigdon Guy, and Leona May Guy; (second row) Charles Henry Guy and Anna Maude Guy.

Born in Ipswich, England, Edmund Randall graduated from St. Mary's College in Moraga and then worked with his brother Samuel on a ranch in Ygnacio Valley. In 1888, the brothers came to Concord to work in the store purchased by their father, Edmund, at the corner of Main and Grant Streets. The store was later moved to the southwest corner of Main and Galindo Streets under the name Randall Brothers General Merchandise Store. The store became the largest store of its kind in the area. As a civic leader and businessman, Edmund's many accomplishments included serving as the first president of the Mount Diablo Union High School Board of Trustees, a county supervisor, president of the Anderson Lumber Company, and on the board of the Alhambra National Mineral Water Company. He was the third mayor of Concord.

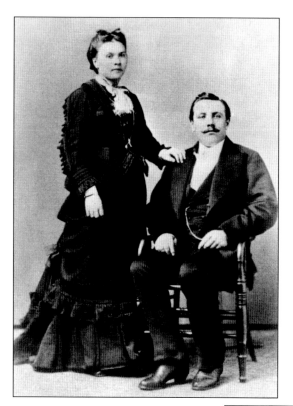

George and Dorothea Russi operated Russi and Griffen's Pacheco Flour Mill. They lived in one of the prominent homes built by Laurence V. Perry, the area's premiere builder.

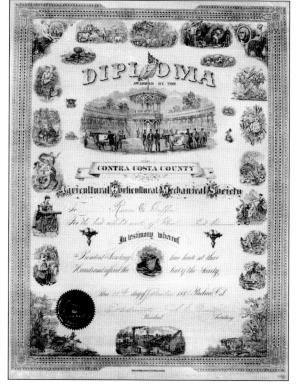

Pictured is a September 11, 1886, diploma awarded by the Contra Costa County Agricultural, Horticultural, and Mechanical Society to Russi and Griffen's Pacheco Flour Mill for best exhibit: a sack of flour. The mill was purchased by George Russi in 1881, and it remained in his family for about 70 years.

St. Michael's Mission in Pacheco began holding church services in 1873. It was torn down, and in 1876, some of its lumber was used to build Queen of All Saints Catholic Church, which was Concord's first church. Queen of All Saints was built as a mission church in 1876 on Salvio Street between East and Colfax Streets and was established as a parish in 1923.

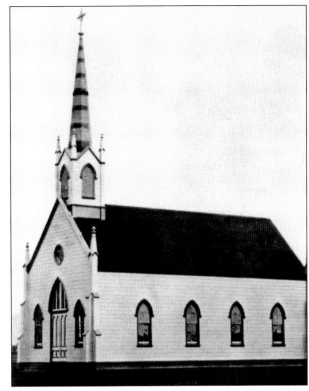

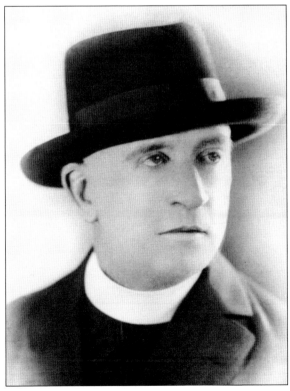

Rev. John J. Powers was the first pastor of Queen of All Saints Church, serving from 1923 to 1925. The church was used until about 1954, when the new church was completed on the corner of Grant and Almond Streets. The new church compound was built to include a school, rectory, and convent.

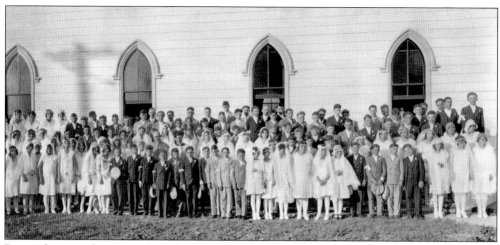

Pictured is a confirmation class of the Queen of All Saints Church from the early 1930s.

Constable Edward P. Jackson was charged with maintaining order in the sometimes wild town of Todos Santos. Constable Jackson married Jettie Jaquith and became Concord's first justice of the peace.

Millers and grain dealers George Russi and his partner Mr. Sonner came to ~~Concord from Paxheim~~ in 1910. The Russi and Sonner Flour Mill was located on the west side of ~~Market Street near the~~ Southern Pacific Depot. The mill was demolished in 1989.

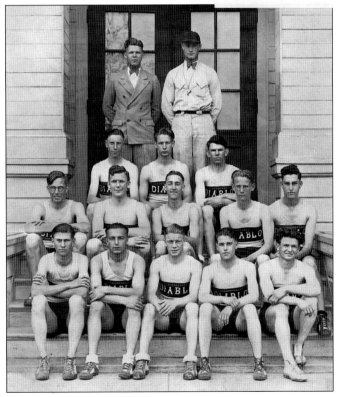

One of the first Mount Diablo High School track teams is pictured here.

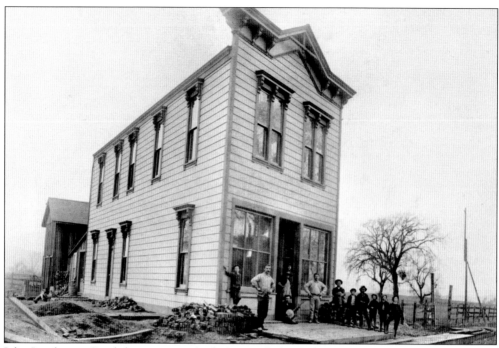

John Lambert, a Swedish immigrant, built Concord's first bakery. The Lambert Bakery Building was constructed in 1879. A two-story brick building, it was located on the north side of Salvio Street just west of Galindo Street.

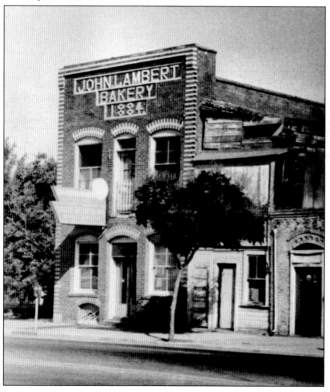

In 1884, John Lambert built a brick building on Main Street behind the original wooden bakery and restaurant building. The business was expanded from just a bakery to include a restaurant downstairs and rooms for rent upstairs. The business was purchased by Antonio Vasconi in 1915.

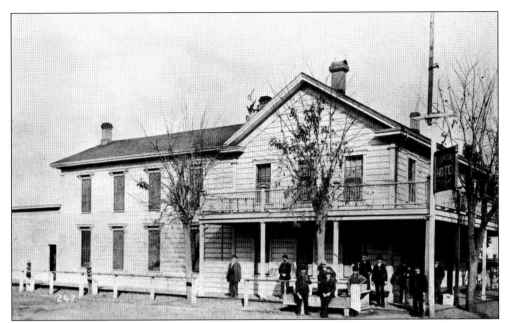

The first hotel in Concord was built in 1869 by Henry Loring and was later purchased in the late 1870s by Philip J. Klein. It was located at the corner of Salvio and Mount Diablo Streets across from Todos Santos Plaza. Called both Klein's Hotel and the Concord Hotel, it was a popular meeting place, and many period photographs show groups of locals posing in front of the hotel.

Klein's Hotel was purchased around 1898 by Joseph F. DeRosa and renamed the Concord Hotel, Bar, and Grill. The first movie "theater" in Concord was an upstairs hall of the hotel, which was used as a dance hall on Saturday nights. The Majestic Theatre opened next door in 1914.

Clark Jaquith and his brother Edward came to Concord from Canada and opened a blacksmith and horseshoeing shop. Clark was also a carriage maker and made a carriage for Fernando Pacheco with a special seat featuring a pull-out rest for Fernando's large stomach.

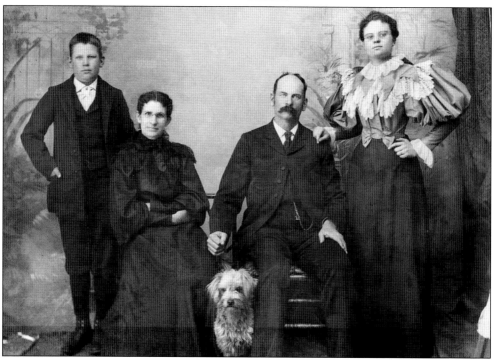

This Jaquith family picture includes, from left to right, Cory Jaquith, aunt Mary, Clark Jaquith, and Jettie Jaquith.

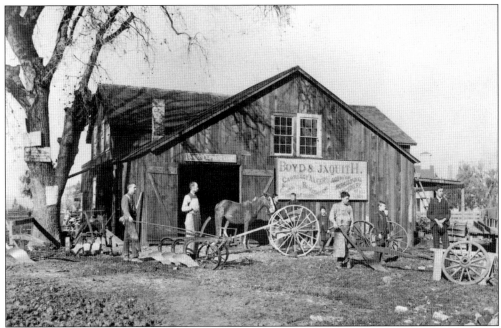

The Boyd and Jaquith General Blacksmith, Carriage Maker, and Agent for Agricultural Machinery of All Kinds was founded in 1880 by Edward and Clark Jaquith. The business was a success, and the brothers hired Joseph A. Boyd, a blacksmith from Quebec. Here in 1880, Joseph Boyd is pictured on the far left, with Clark Jaquith to the right of him.

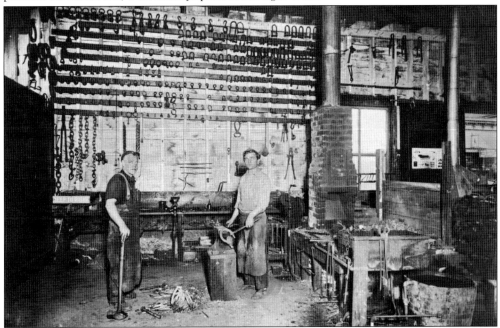

The Boyd and Jaquith shop was located at the corner of Salvio and Galindo Streets. This interior image was taken around 1900. Originally a blacksmith, the successful shop manufactured and repaired farm equipment and harnesses and was the first car dealer in Concord, selling Studebakers and EMFs.

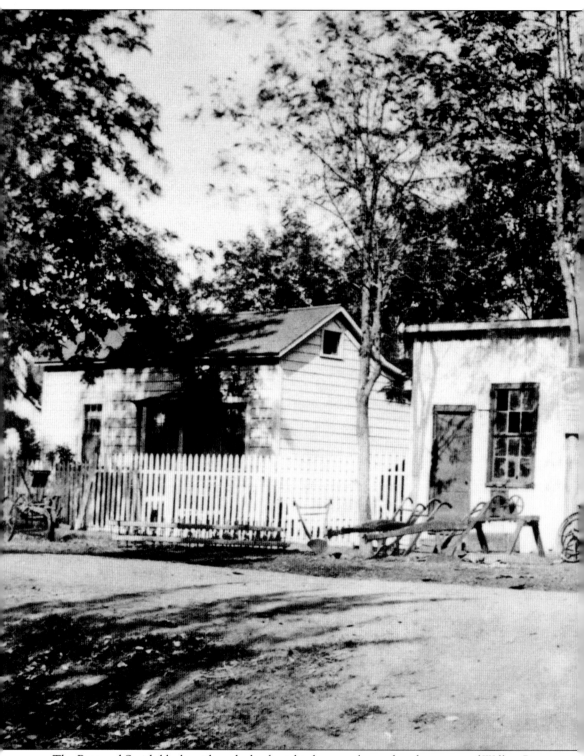

The Bott and Smith blacksmith and wheelwright shop was located at the corner of Willow Pass Road and Grant Street beginning in 1884. It was originally established by Charles Bente and

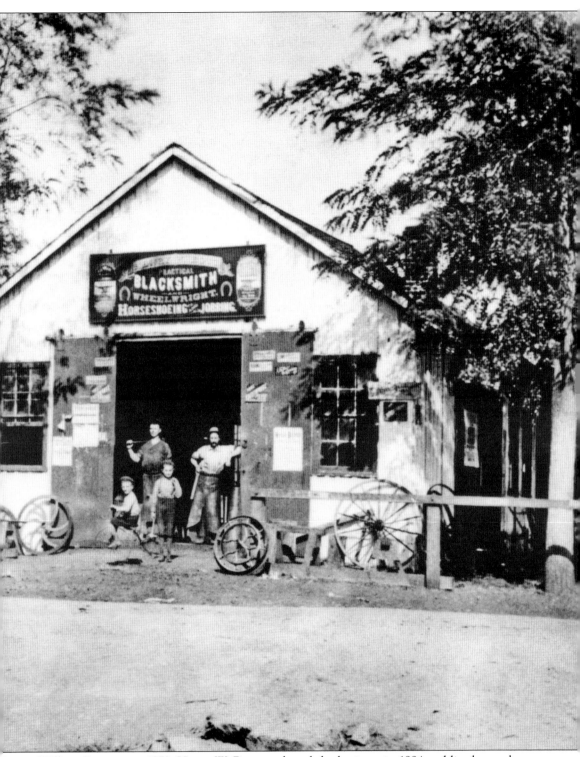

William Bauman in 1872. Henry W. Bott purchased the business in 1884 and lived next door, operating the shop until 1937. He stands here with his partners and children.

Henry W. Bott served on the first Concord Board of Trustees and continued as a trustee for 35 years. He was the fifth mayor of Concord, serving from 1921 to 1922.

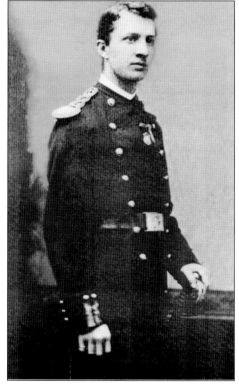

Dr. Hayward Glazier Thomas, lieutenant of the Boston Latin School Regiment, is shown here in 1882. Dr. Thomas arrived in Concord around 1890, then decided to return to medical school and gave his practice to Dr. Francis Neff, who served the residents of Concord for over 30 years.

Joseph Arthur Boyd, a blacksmith from Quebec, arrived in Concord at the age of 25 and was hired by the Jaquith brothers. He married the Jaquiths' niece Ency in 1885, and they had nine children.

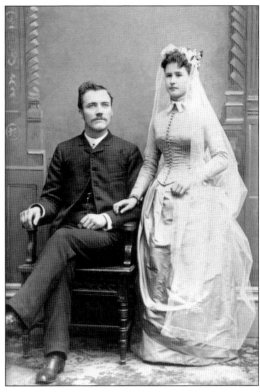

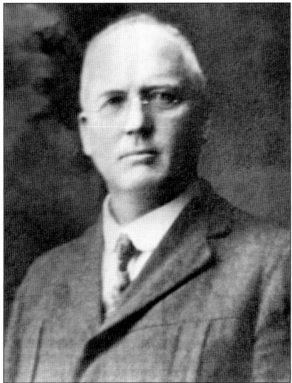

Joseph Boyd was an early leader in the formation of the town of Concord and Concord civics. He was the first mayor of Concord. Joseph Boyd served as a director of the Bank of Concord and was president of the local Red Cross. The Boyd family owned the first car in town.

35

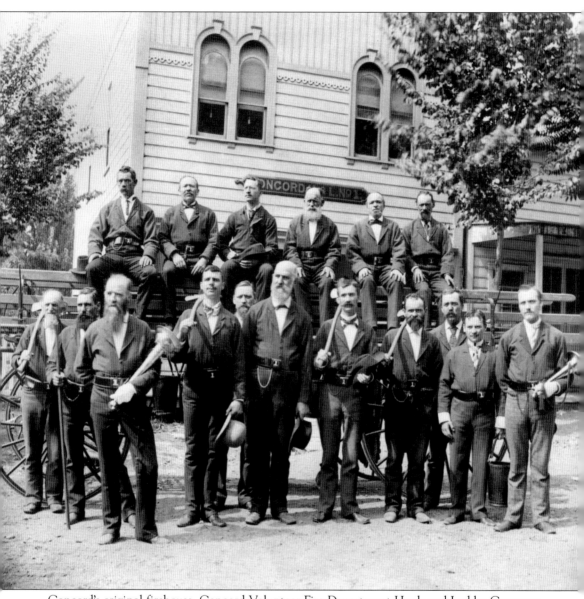

Concord's original firehouse, Concord Volunteer Fire Department Hook and Ladder Company No. 1, was built in 1883 on Mount Diablo Street between Salvio Street and Willow Pass Road. The land cost $50, and construction costs totaled $870. From left to right are (first row) H. J. Robinson, J. Fisher, justice of the peace John Burke, Thomas Smith, Charles Stultz, foreman Henry J. Nelson, James Sheehan, Frank Charles, Myron Breckenridge, Gus or Fred Klein, and Joseph Boyd; (second row) Henry Ivey, Phillip Klein, Dr. Hayward G. Thomas, Manuel Sherman, John Stultz, and Joe Arrellano.

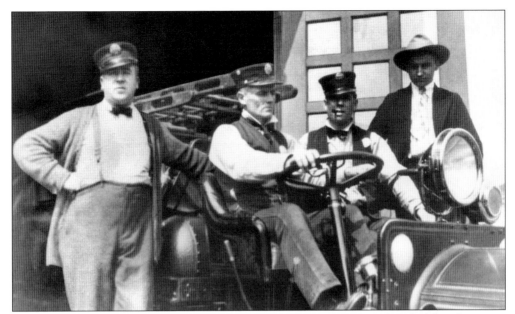

Concord Fire Department Engine Company No. 1 is shown in 1927 with a Cadillac American La France engine with a 300-gallon-per-minute pumper.

Antonio and Marcellina Ginochio arrived in Concord from Italy around 1867. Their large farm on Cowell Road specialized in vineyards and vegetables. They had nine children, five sons and four daughters. Three sons owned the Concord Meat Company on Mount Diablo Street.

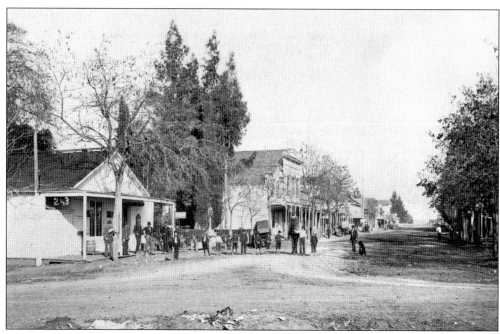

Main Street Concord is pictured in 1884; it was later renamed Salvio Street after Salvio Pacheco. The original photograph was owned by Frederick Galindo. At the head of the street is the first business to be located in Concord, Sam Bacon's Fancy Groceries, which advertised fruit, vegetables, candies, pipes, tobacco, cigars, stationery, and ice cream.

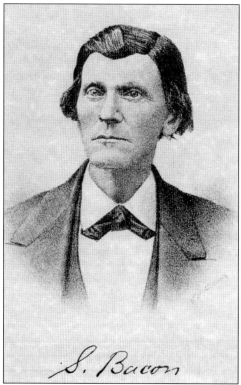

Sam S. Bacon was Concord's first businessman. He originally owned a stationery store in old Pacheco Town. When Salvio Pacheco offered $1 lots in the new town of Todos Santos, Sam moved his building to a prime lot on Main Street by the plaza. He built his home next door.

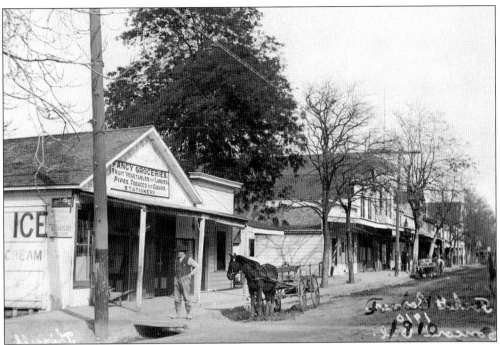

Main Street became Salvio Street and was still anchored by the original Sam Bacon grocery store on the left. Dr. George McKenzie's office is next door. Sam became the first postmaster and justice of the peace of Concord.

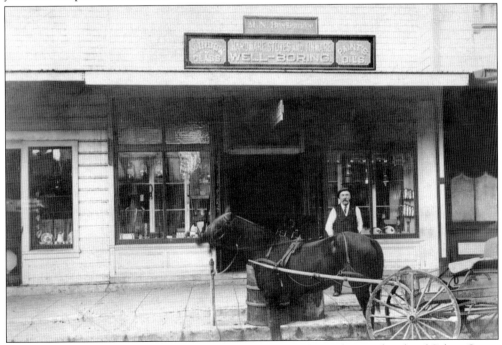

Myron Breckenridge stands in front of his hardware store on the north side of Salvio Street in the early 1880s. The store advertises window glass, paints and oils, stoves and tinware, and well-boring.

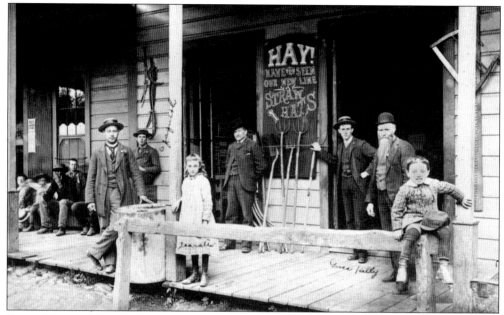

Barney Neustaedter's Pioneer Store, which was located on the south side of Main and Salvio Street in 1890, advertises, "Hay! have you seen our new line of straw hats." Gathered on the front porch from left to right are Mitch Neustaedter, Clark Jaquith leaning against the building, Jeanette Neustaedter, Bernhardt Neustaedter, Gus Kelly with his hand on the rail, justice of the peace Judge John J. Burke, and Elie Lobree. The store was destroyed in the downtown fire of 1917.

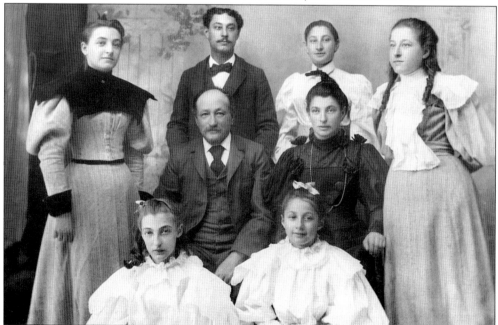

Barney Neustaedter was a German immigrant who ran his general store with the help of his wife, Adeline, and his children: from left to right, (first row) Jeanette and Etta; (second row) Ray, Mitch, Annie, and Sadie. Annie ran a millinery store inside the Pioneer Store, and another sister, Rachel, made the hats.

Three

THE AMERICANIZATION OF
THE CONCORD VALLEY

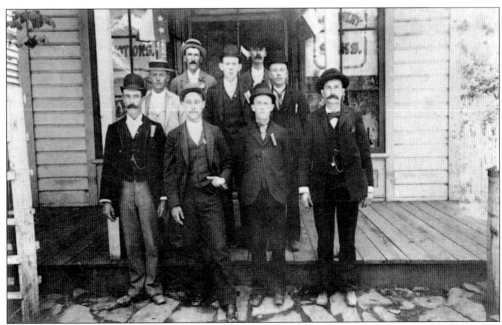

Pictured from left to right, Tom McKenna, Edwin Majors, Jasper Wells, James Daley, George Condi, Charles Bibber, Mitch Neustaedter, Forbes Guy, and Henry Bott, all native Californians, were members of the Concord Parlor of the Native Sons of the Golden West.

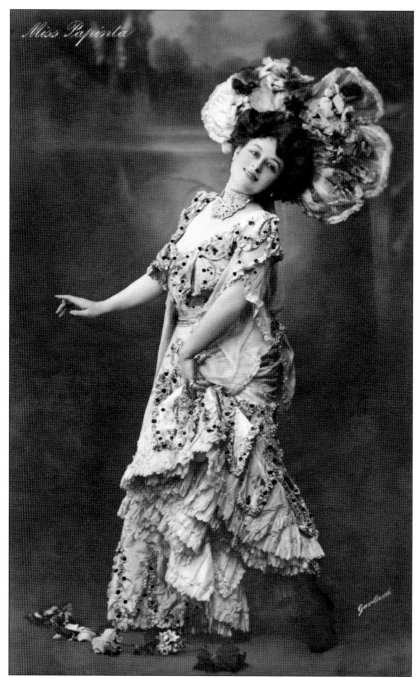

Caroline Hipple Holpin, known as "Papinta the Flame Dancer," was an Indiana native. Convinced by her husband, a lover of horse racing and the theater, she became a performing artist. William found a teacher and bought a complicated set of mirrors called the "crystal maze," which reflected light from calcium arc lamps. During her act, Papinta managed to keep 50 yards of silk in motion. Her popularity took her to the capitals of Europe, Cape Town, and around the United States. The *Richmond Recorder* described her acts as "an ever glittering spectacular with roses and lilies and butterflies and birds that mysteriously rose and formed flames of fire."

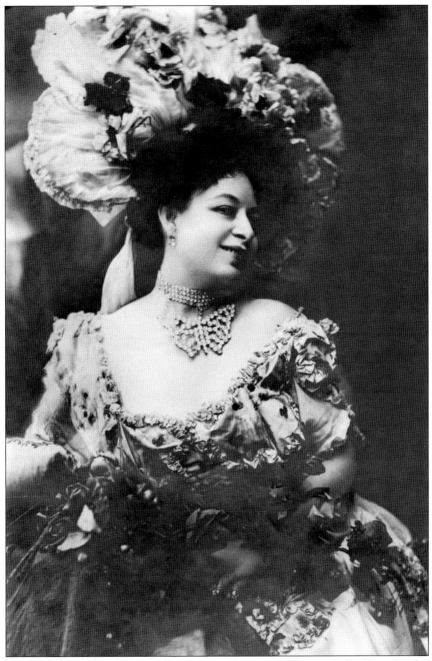

In the late 1890s, Papinta and William bought over 100 acres in Ygnacio Valley/Pine Creek Canyon to raise racehorses, establishing the Papinta Stock Farm. Papinta became Concord's first celebrity and was given much attention by the rural town and local press. In March 1905, while performing in New York, Papinta received news that William had died suddenly of "acute gastritis" at age 35. She returned home only to find her important papers missing and a claim by William's father for her ranch. The case took a year and a half and was settled in her favor. Shortly thereafter on August 10, 1907, Papinta died just after finishing a performance in Dusseldorf, Germany. Her death was guessed to have been caused by the fumes from her arc lamps.

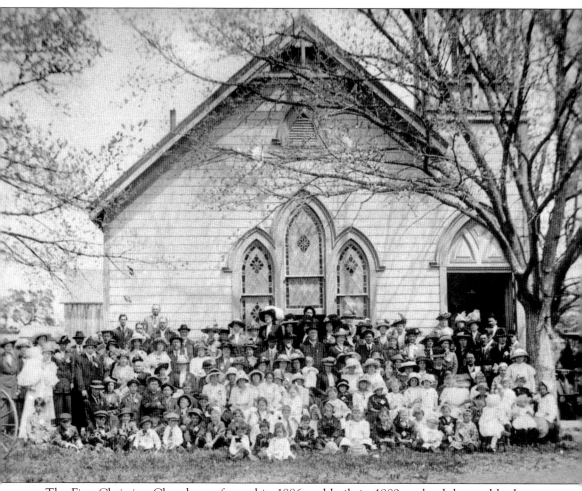

The First Christian Church was formed in 1886 and built in 1889 on land donated by Jerry Morgan of Clayton. It was located at the corner of Mount Diablo and Lincoln Streets (Concord Boulevard). The congregation was determined to pay off the $1,500 construction debt as quickly as possible. Mrs. Henry Whitman and Mrs. Charles McCellan drove the streets of Concord in a horse-drawn carriage collecting donations. Everyone, including Catholics and Presbyterians, donated, and the church become debt free. It remained at this location until 1955. This picture of the congregation was taken in 1912.

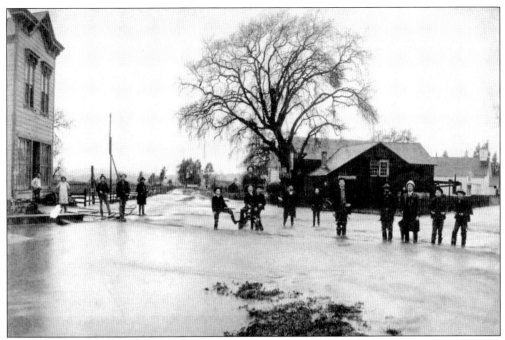

Salvio Street flooded in 1890. The Lambert Bakery is located on the left and was damaged by the flood. Owner John Lambert stands in front of the bakery in a white apron surveying the damage with Clark Jaquith, Henry Bott, Tom Smith, and Dr. Hayward G. Thomas.

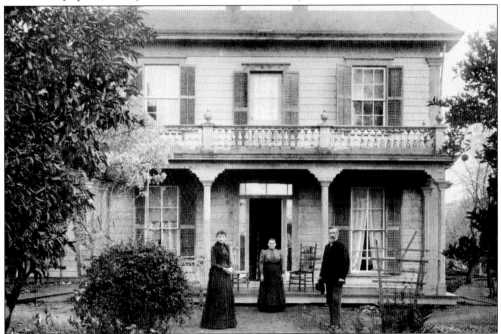

The Beebe family stands in front of their home, which was later to become Concord's first historic landmark. Built in 1868 by Benjamin F. Beebe as his family residence at 1465 Pacheco Road (Concord Avenue), it was moved to its present location at 1921 Concord Avenue in 1996 by Marc and Carole Willis for restoration.

Dr. Francis F. Neff and Dr. George McKenzie were the Concord area's only doctors from 1890 until about 1909. Dr. McKenzie, pictured here, also handled the local dental needs, as Concord had no dentist. He also fitted glasses and handled all medical lab work. A bicycle-powered windmill in his backyard generated electricity for his X-ray machine.

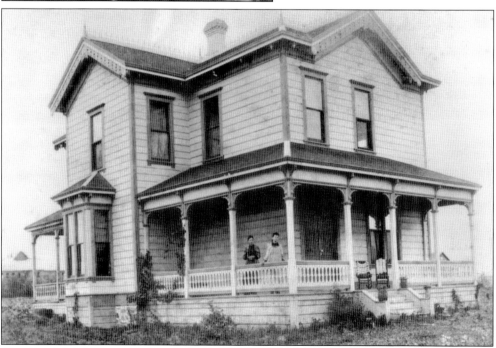

The Goodale/McKenzie/Collins home was located at the corner of Salvio and East Streets. Residents of this home included Dr. George McKenzie and Mr. Goodale, who was an early business partner of Bernhardt Neustaedter.

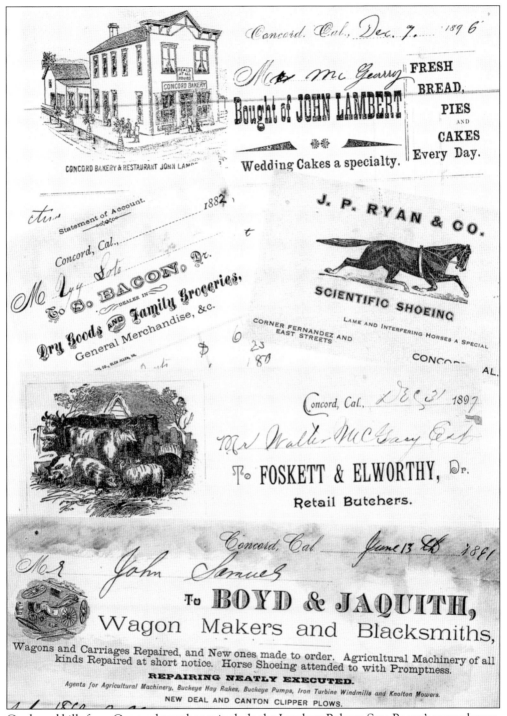

Concord, Cal., Dec. 7. 1896

Mrs Mc Geary

Bought of JOHN LAMBERT

FRESH BREAD, PIES AND CAKES Every Day.

Wedding Cakes a specialty.

CONCORD BAKERY & RESTAURANT JOHN LAMB...

Statement of Account. 1882

Concord, Cal.,

Mr Ayy Soto

To D. BACON, Dr.
DEALER IN

Dry Goods and Family Groceries,
General Merchandise, &c.

J. P. RYAN & CO.

SCIENTIFIC SHOEING

LAME AND INTERFERING HORSES A SPECIAL

CORNER FERNANDEZ AND EAST STREETS

CONCORD, CAL.

Concord, Cal., DEC 31 1897

Mr Walter McGary Est

To FOSKETT & ELWORTHY, Dr.

Retail Butchers.

Concord, Cal June 13 th 1881

Mr John Samuel

To BOYD & JAQUITH,
Wagon Makers and Blacksmiths,

Wagons and Carriages Repaired, and New ones made to order. Agricultural Machinery of all kinds Repaired at short notice. Horse Shoeing attended to with Promptness.

REPAIRING NEATLY EXECUTED.

Agents for Agricultural Machinery, Buckeye Hay Rakes, Buckeye Pumps, Iron Turbine Windmills and Knolton Mowers.

NEW DEAL AND CANTON CLIPPER PLOWS.

Cards and bills from Concord merchants include the Lambert Bakery, Sam Bacon's general store, J. P. Ryan and Company Scientific Shoeing, Foskett and Elworthy butcher shop, and Boyd and Jaquith blacksmiths.

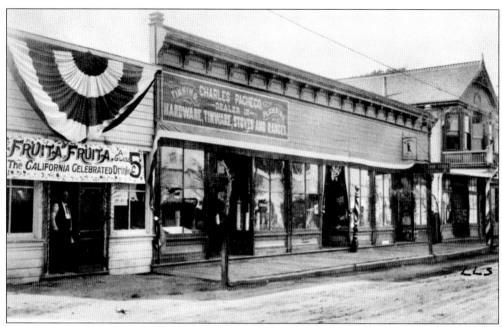

Businesses on Old Pacheco Road, now Concord Avenue, included, from left to right, the Holler Fruit Shop, selling "Fruita Fruita The California Celebrated Drink" for 5¢ a glass; the Charles Pacheco Hardware Store; a barbershop; the Daneri Shop; and the Holler home. The Pacheco Hardware Store advertises hardware, tinware, stoves and ranges, tinning, and plumbing supplies.

Horgan's Saloon, with a meeting hall upstairs, was located on Salvio Street between a china shop and Emma Sperry's Millinery. Adult gatherings included dinners and card parties in the meeting hall. The owner was Pat Horgan, a veteran of the Spanish-American War.

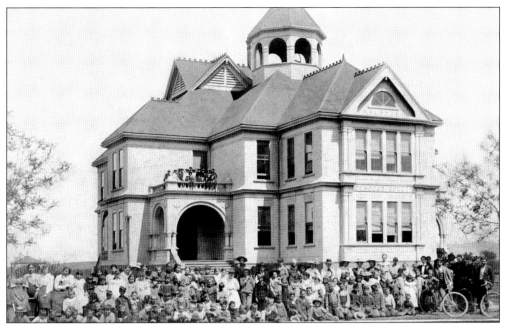

Determined to have the finest building to house their growing student population, the City of Concord raised funds to build a new grammar school on Willow Pass Road in 1892. Teachers would include members of the Gehringer, Jaquith, Boyd, Ballenger, Soto, and Thurber families.

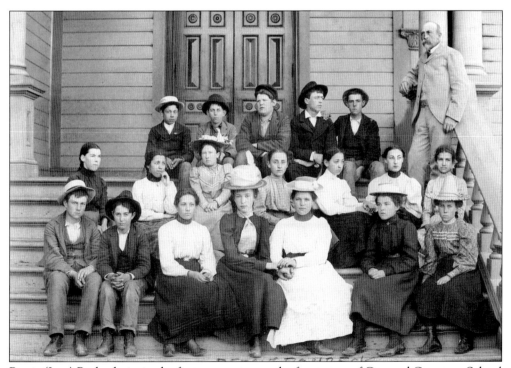

Bessie (Ivey) Brubeck sits in the first row center on the front steps of Concord Grammar School in November 1898.

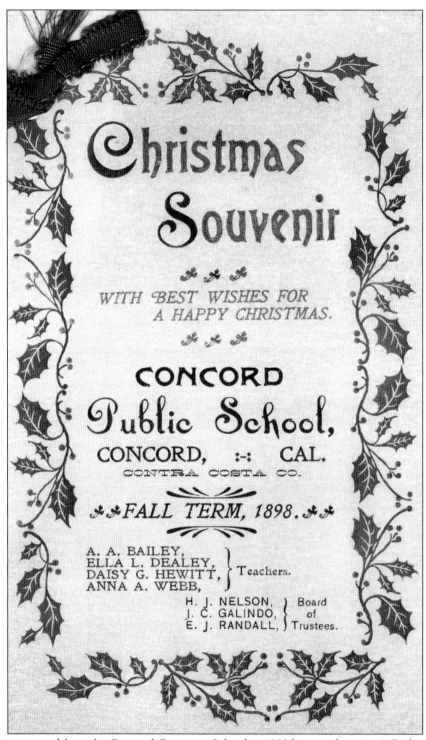

Christmas Souvenir

WITH BEST WISHES FOR A HAPPY CHRISTMAS.

CONCORD

Public School,

CONCORD, :-: CAL.

CONTRA COSTA CO.

FALL TERM, 1898.

A. A. BAILEY,
ELLA L. DEALEY,
DAISY G. HEWITT, } Teachers.
ANNA A. WEBB,

H. J. NELSON, } Board
J. C. GALINDO, } of
E. J. RANDALL, } Trustees.

A Christmas card from the Concord Grammar School in 1898 lists teachers A. A. Bailey, Ella L. Dealey, Daisy G. Hewitt, and Anna A. Webb. The board of trustees included Henry J. Nelson, John C. Galindo, and Edward J. Randall.

50

Four

CONCORD IN
THE NEW CENTURY

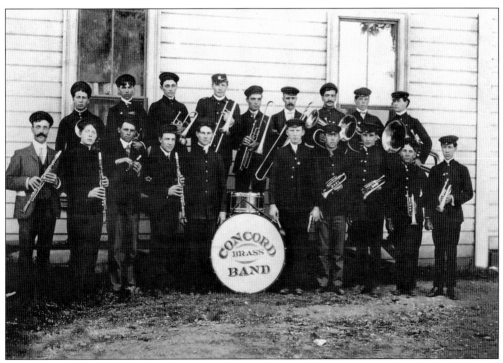

The Concord Band played on Sundays in Todos Santos Plaza and was very popular at special events and funerals. In 1900, the band included (first row) Manuel Nunez (far left), Paul Keller (fourth from left), and Walter Keller (far right); (second row) Frederick Galindo (third from right) and Joe Levada (fourth from right).

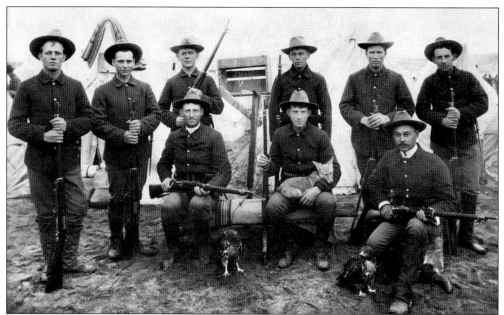

The Concord veterans of the Spanish-American War include, from left to right, (seated) Charles Clanton, Bernard Tierney, and Mitch Neustaedter; (standing) Arthur Downey, Andy Hunt, Pat Horgan, Hugh McClellan, Gus Klein, and Tom Tierney. Along with George Bauman, they all returned from the war except for Hugh McClellan, who was given Concord's first military funeral.

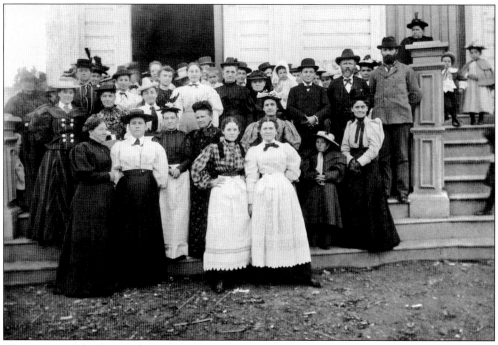

The women of the Concord area formed a Red Cross Society in 1898 to contribute to the Spanish-American War effort. Here they stand in front of the Odd Fellows Hall. Mae Guy stands all in white at the center of the group.

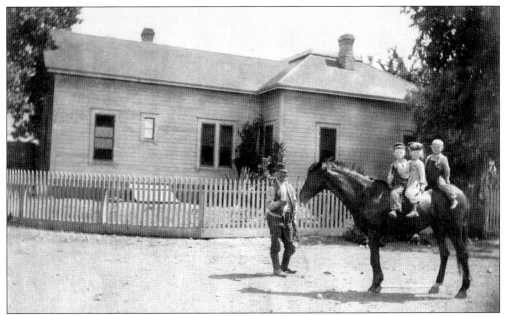

Henry G. Bollman and Martha E. Bollman's farm was located in eastern Concord. The farm sold butter, cream, eggs, and meat to the people of Concord and hay for horses in San Francisco. In this photograph from the mid-1890s, Henry watches his children Ralph, Etta, and Diedrich on horseback. Ralph took over the farm and dairy business in 1923 and operated it until the navy acquired the land in 1944 to expand the naval base.

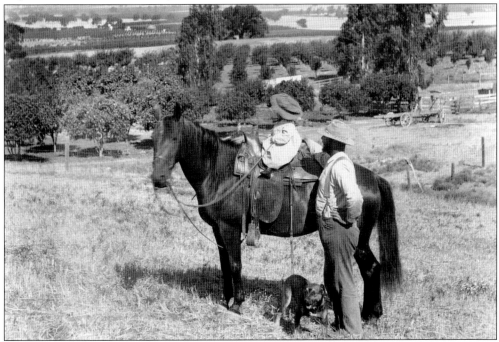

Charles Dunn is shown with his niece Edna Thurber on horseback surveying the Breeze Ranch in the late 1890s. Located in the southeast of Concord, the ranch land is now part of Boundary Oaks Country Club in Walnut Creek.

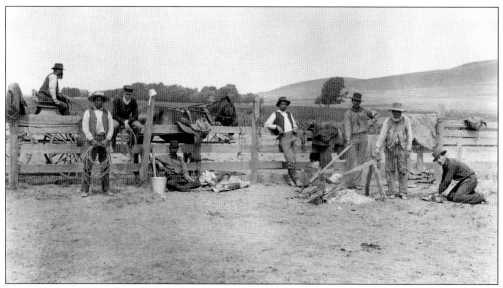

Workers are pictured on Government Ranch in north Concord, near Bates Avenue and Port Chicago Highway. A 3,000-acre territory forming the high land between Mount Diablo and Walnut Creek was purchased by two officers of the Quartermaster's Department of the U.S. Army, Majors Allen and Loring, for $12,500. At one time, army mules were pastured on their land, and the name "Government Ranch" was adopted by the public. The government never actually owned or leased the property. After purchasing the land in 1851, the majors bought several ready-built buildings from Norway, which were assembled by number without nails.

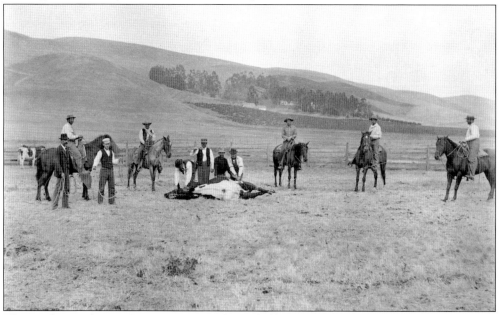

This cattle roundup on Government Ranch was held on August 28, 1895. Around the downed cow are Frank Foskett, Herbert Elworthy, J. M. Walker, Charles Dunn, Buck Mitchell, Jacinto Soto, Filano Soto, Bonifacio Pacheco, Harry Keller, Harry Sybrian, and A. Nickerson. Major Allen never lived on the ranch but acquired Major Loring's share on his death. The property was sold several times and was eventually acquired by Bert Elworthy.

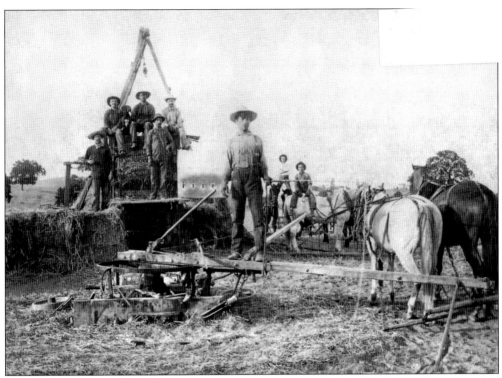

Concord's first industry was farming. Wheat was the principal crop. Boyd "Uncle B" Murchio stands on his hay rake on the Murchio Ranch.

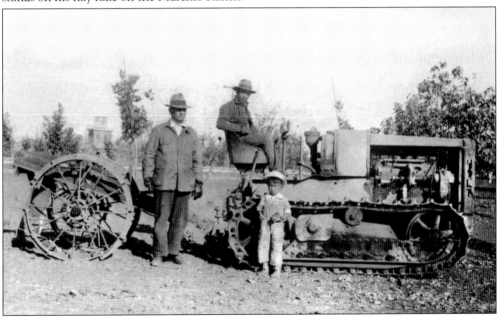

Concord ranches, including Elwood Glazier's ranch, pictured here, produced hay that was sold in San Francisco and around the Bay Area. Elwood Glazier stands with one of his tractors on his ranch. The Glazier ranch was also known for its prize tomatoes. The ranch was severely flooded in 1938.

John Enea is shown with his family on the Enea Farm, located on Seal Bluff Road in northwest Concord.

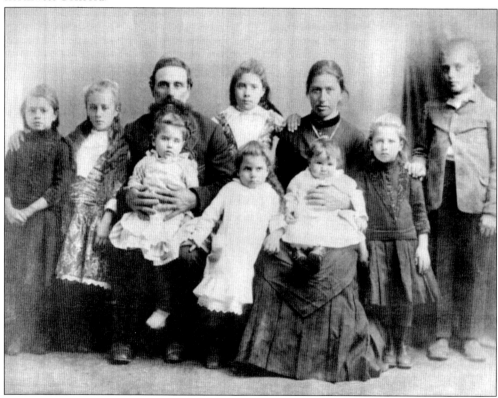

Manuel and Nora Nunez sit with their children, who they raised in their home on Salvio Street, which was later moved to Almond Avenue when the theater was built. Isabel (Nunez) Perry sits on her father's lap. Children of immigrants from the island of St. George in the Azores, the Nunez family homesteaded much of the land along Morgan Territory Road. Later they acquired the Rhine home in Clayton.

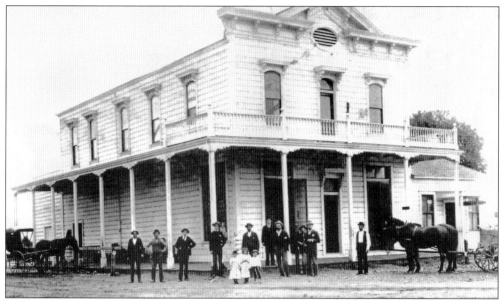

Edward J. Randall and his brother Samuel Randall operated the Randall Brothers Mercantile Store (second location) on the southwest corner of Salvio and Galindo Streets. They sold general merchandise, grain, hay, coal, and even insurance. By 1902, they were the most successful general store in the area. It would later become the Concord Department Store.

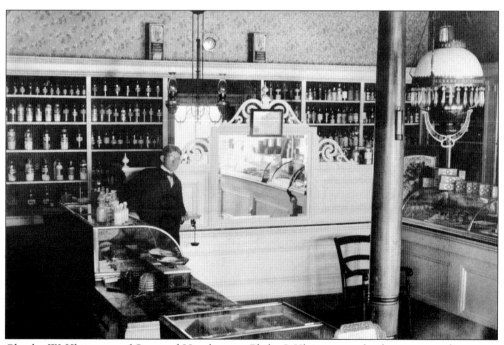

Charles W. Klein, son of Concord Hotel owner Philip J. Klein, opened a drugstore on the corner of Salvio and Mount Diablo Streets in 1902. Charles leased the former location of the Navas and Beebe General Merchandise Store from George Rogers.

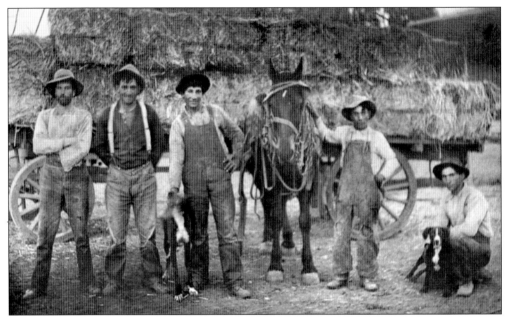

Antonio and Marcellina Ginochio arrived in Concord from Italy around 1867. Their large farm on Cowell Road specialized in vineyards and vegetables. Three of their sons—John, Louis, and Peter—expanded the family farm to include wheat, walnuts, and cattle ranching. The three brothers are pictured hauling hay with two workers in 1905. The farm was located near Cowell Road and Babel Lane.

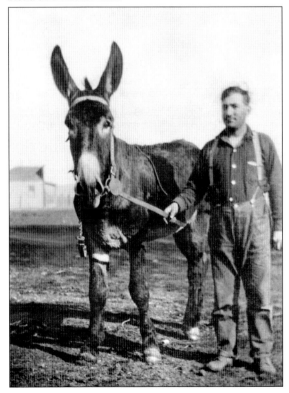

Antonio and Marcellina Ginochio had nine children, five sons and four daughters. Their son Louis Ginochio stands here near what is now Cowell Road and Babel Lane.

WILL BUILD A HIGH SCHOOL.

Is the Decision of the Trustees of the Mount Diablo High School

At a meetnig of the trustees of the Mou.t Dia' lo Union High School district, held at the school house, on Saturday Feburary 14th, it was formerly decided to erect a High School Building. Messrs Geo Whitman, Andrew Gehringer and J. H. Parkinson were appointed as a committee to secure a site for the building.

The sentiment of the trustees seem to be that the necessary money be secured by the sale of bonds. The calling of an election for the issuing of bonds, has been deferred until the exact amount needed could be determined. It is estimated that the cost of erecting a good substantial building, of brick and stone, with ten rooms furnished complete throughout, will be a little less than $20,000.

By 1900, there were only 12 high schools in California. The closest to Concord were in Oakland and Berkeley. In 1901, voters in Concord and Walnut Creek established the Mount Diablo Union High School District, with classes held in temporary locations. In 1903, a local newspaper ran a story about the decision of the trustees of the school district to build Mount Diablo High School.

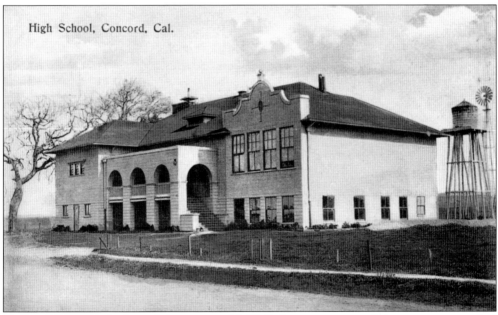

High School, Concord, Cal.

George Whitman, Andrew Gehringer, and J. H. Parkinson comprised the committee to find a location for the new high school. Land was donated by A. W. Maltby. The estimated cost of erecting a good substantial building of brick and stone with 10 rooms completely furnished was a little less than $20,000. When the school was completed, C. W. Klein, the prescription druggist, commissioned this postcard.

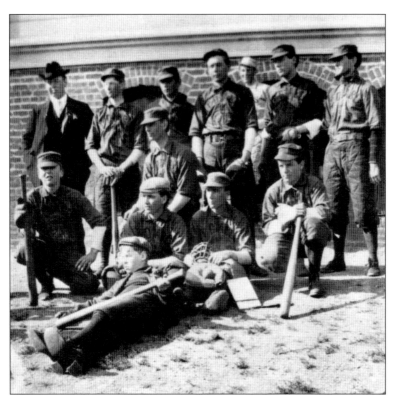

The first baseball team at Mount Diablo High School was founded in 1904. This picture shows, from left to right, Marius Scamell lying down in front; Ralph Wight in the center; (first row) Blalock Putnam, Frank Loucks, Ben Jones, and Ted Wiget; (second row) Chester Hook, Clifford Foskett, Charles Crenna, Alvin Svenson, Theodore Russi, and Peter Thomson.

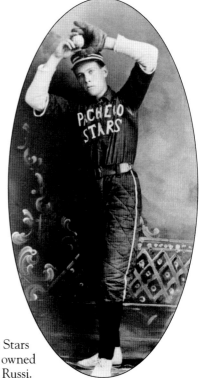

Theodore Russi went on to play baseball for the Pacheco Stars baseball team. His parents, George and Dorothea Russi, owned the Pacheco Flour Mill. He was married to Alice McNeil Russi.

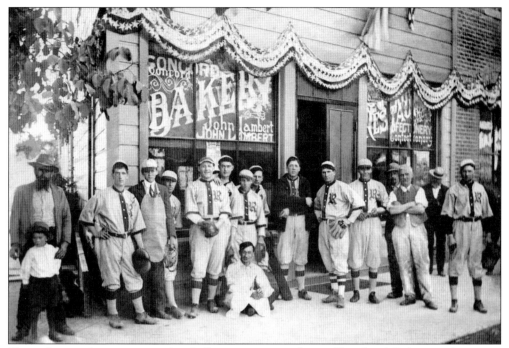

Shown here is the community baseball team posing in front of Lambert's Bakery at the corner of Concord Avenue and Salvio Street around 1900. The adjacent buildings, street, and trees did not exist when Lambert's Bakery was built in 1884.

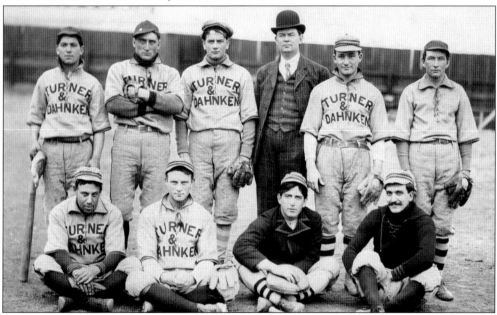

Frederick Galindo, the grandson of Francisco Galindo, was born in 1875 in the Pacheco Adobe, soon after his family moved to the Galindo home. He graduated from St. Mary's College in 1897 or 1898. Frederick played semi-professional baseball for St. Mary's College and both the Concord and Antioch baseball teams. One team Frederick played for was sponsored by the famous movie distributors Turner and Dahnken. Frederick sits on the front right.

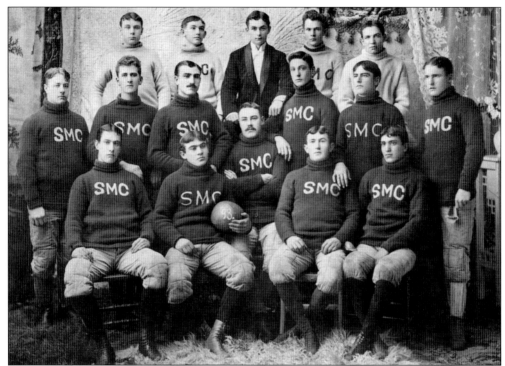

St. Mary's College's first American football team of 1893 is pictured here. Varsity quarterback Frederick Galindo sits in the first row on the far right. From left to right are (first row) Anthony A. Mogan, Richard Harry Dunn, J. Robinson, and Francis J. Griffin; (second row) Hugh Joseph McIsaac, James Edward Taylor, Peter John Soracco, Charles F. Miller, Hugh S. Dimond, and J. Rickey; (third row) William Edward Donovan, William J. Hanlon, manager Francis James Richardson, F. McNeill, and John Francis Sullivan.

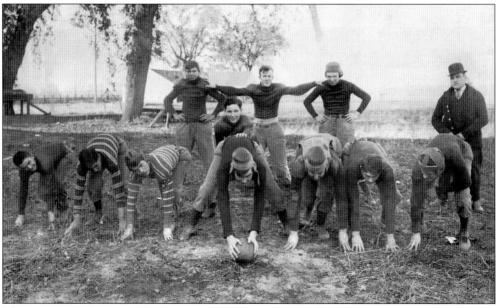

The Mount Diablo High School football team is shown here in 1911.

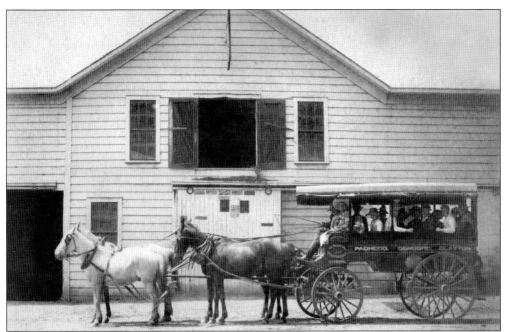

Available for rent, Henry Ivey's four-horse stagecoach stands in front of the Mahoney and Ivey Livery Stable on the north side of Salvio Street opposite Todos Santos Plaza in the early 1900s. It advertises transportation to Pacheco, Concord, and Clayton. Henry Ivey was the father of Bessie Brubeck and grandfather of jazz pianist David Brubeck.

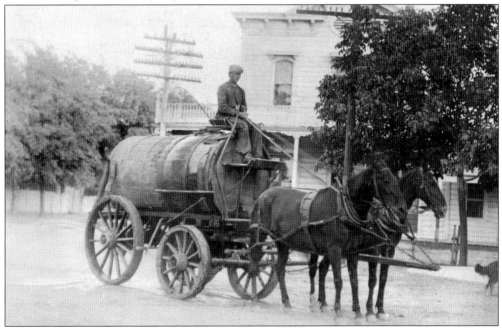

Willie Johnson drives his water wagon on Salvio Street toward Pacheco Street just past the intersection of Galindo Street. The Randall Brothers store is in the background. This vintage postcard was actually mailed by Willie Johnson to Helen Woolley of Berkeley telling her that he is pictured on the postcard with his water wagon and inquiring after her and her mother.

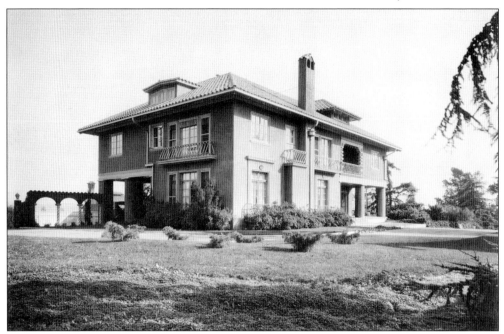

Adolphus William Maltby, the wealthy owner of the Plaza Hotel in Chicago, had always dreamed of becoming a California rancher. At the age of 50, he traded his hotel to his friend Sam Hopkins, owner of the Mark Hopkins Hotel in San Francisco, for a huge parcel of land near Concord. Here he built a 26-room mansion on a hill with an unobstructed view of Mount Diablo.

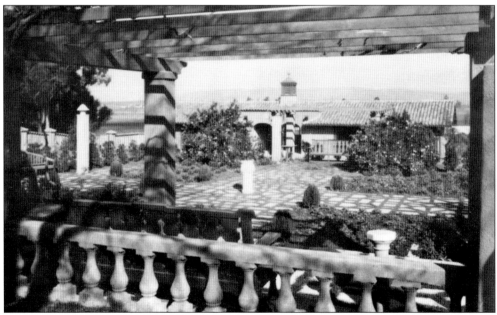

Adolphus and his wife, Eleanor, added to their land by purchasing the adjacent land from Maria Concepcion Soto, one of Salvio Pacheco's daughters and widow of Presentation Soto. This brought the ranch up to 800 acres. Adolphus was very successful at ranching and was instrumental in bringing the Oakland, Antioch, and Eastern Railroad to Concord. This picture shows the sunken garden at the mansion.

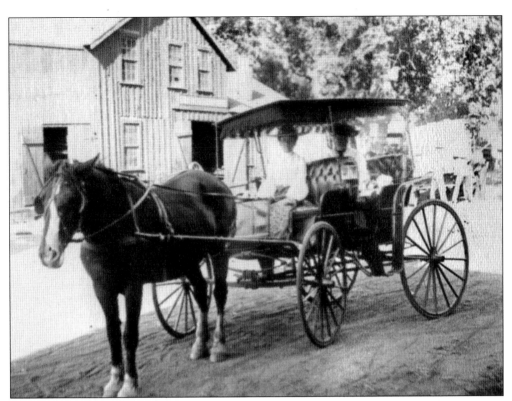

Anita Pacheco drives Grandma Pacheco and a very young Charlie Pacheco on Concord Avenue at Pacheco Road. Charles would later own the Charles Pacheco Plumbing Company on Concord Avenue.

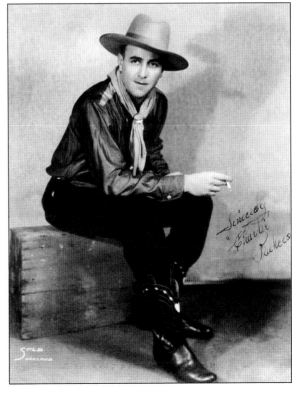

Charlie Pacheco is shown here around 1925.

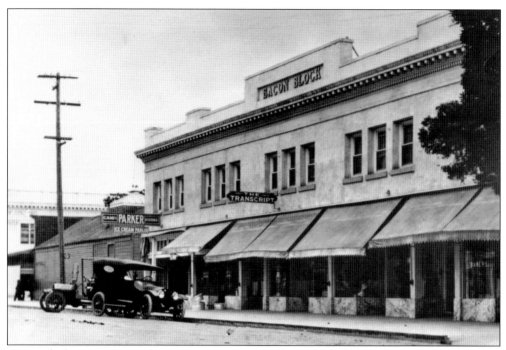

Concord's first newspaper, the *Concord Sun*, was published by S. Fargeon from 1881 to 1884. In 1886, Hart A. Downer acquired the newspaper and renamed it the *Concord Transcript*, which is still published today. This photograph was taken in 1905.

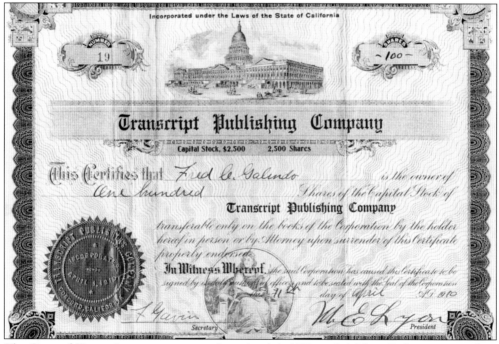

The *Concord Transcript* was incorporated on April 1, 1910, with Melvin E. Lyon as president and issued 2,500 shares for $1 per share. Frederick Galindo owned 100 shares of the "Transcript Publishing Company."

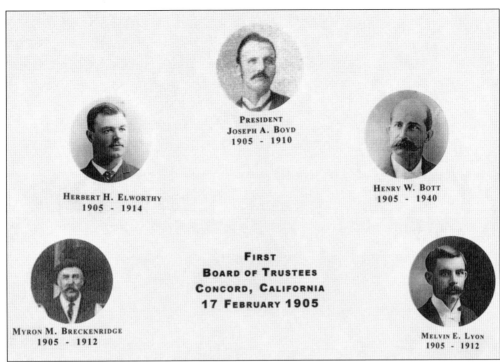

Concord was incorporated in 1905, and five trustees were elected to organize the new town and its laws. These included hardware store owner Myron M. Breckenridge, banker Herbert H. Elworthy, blacksmiths Joseph A. Boyd and Henry W. Bott, and builder Melvin E. Lyon.

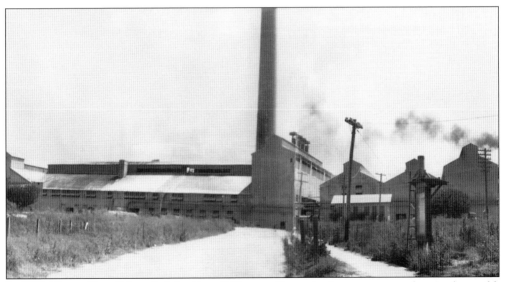

In 1908, Henry Cowell founded the Cowell Cement Plant, the largest cement plant in the world. Workers lived on-site in Cowell "village." The dust from the plant was a terrible nuisance to Concord farmers until 1933, when then-attorney John Garaventa successfully represented the farmers in court and the plant was required to install dust collectors. The plant closed in 1947 after a strike, and both the plant and village were torn down in the 1970s. The smokestack remains and has become a local landmark.

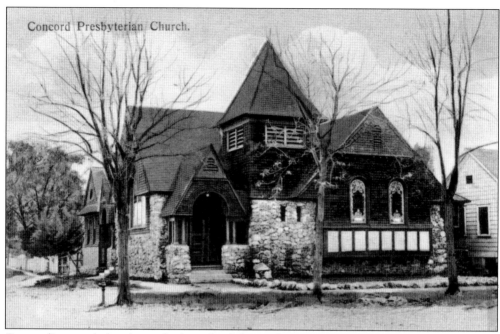

Concord Presbyterian Church.

Concord's second church was built on land donated at 551 Galindo Street by Sam Bacon for Presbyterian services in 1883. It was rebuilt in 1906 at the corner of Salvio and Colfax Streets, as pictured here, and was destroyed by fire in 1915.

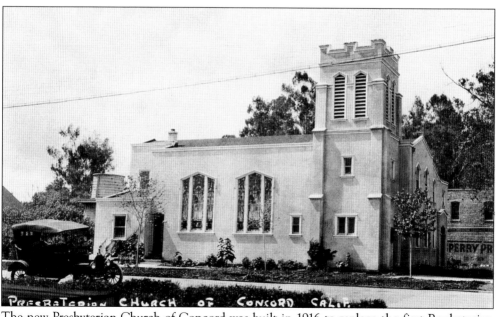

The new Presbyterian Church of Concord was built in 1916 to replace the first Presbyterian Church, which burned down in 1915. It was used until replaced in 1954 by a larger building.

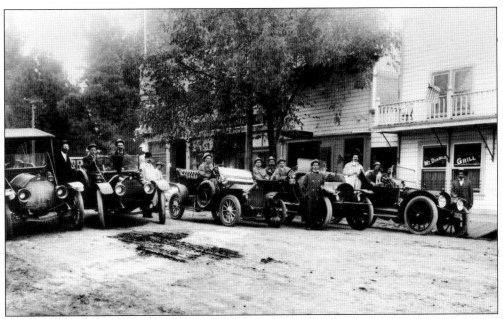

Five automobiles line up on Main Street (now Salvio Street) in 1905 in front of the Concord Bank, Concord Mercantile, Union Shaving Parlor, and the Mount Diablo Grill and Hotel.

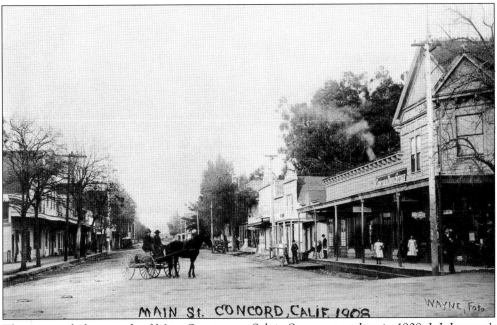

This postcard photograph of Main Street, now Salvio Street, was taken in 1908. J. J. January's Concord Drug Store is located at the front right, followed by the post office, the Union Saloon, the office of justice of the peace John J. Buche, another saloon, the Neustaedter store, Mount Diablo Hotel, and Mrs. Henry Nelson's millinery store.

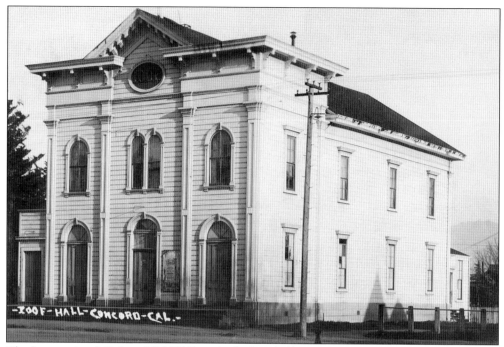

The International Order of Odd Fellows built their hall on Salvio Street at Colfax Street. The hall was used temporarily by Mount Diablo High School for chemistry and physics classes around 1904.

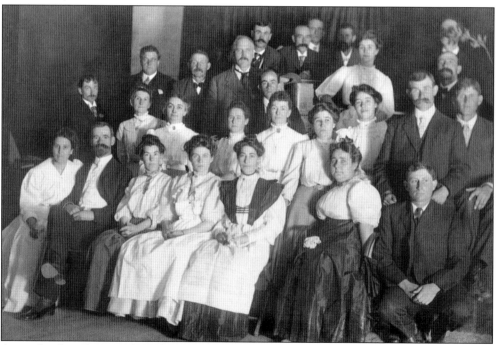

A membership photograph of the Odd Fellows was taken in 1908 that includes Dr. Francis and Annie Neff, Rose Lambert, Mrs. A. C. Gehringer, Mrs. Frank Kellogg, William Straight, Charles and Mary Bibber, Mrs. Wells, Ency Boyd, Mr. Knoff, Henry Bott, and Joseph Boyd.

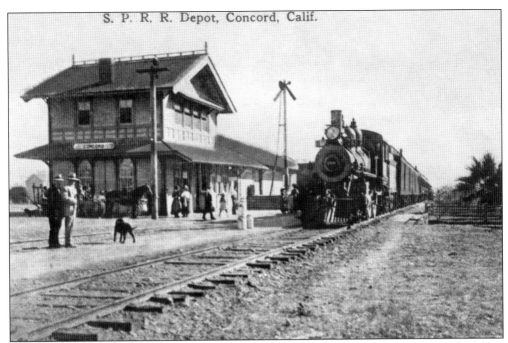

S. P. R. R. Depot, Concord, Calif.

The San Ramon branch of the Southern Pacific Railroad was built in 1896 and stretched from Avon to San Ramon, then continued to Pleasanton in 1909. Concord's Southern Pacific Railroad Depot was located on Main Street.

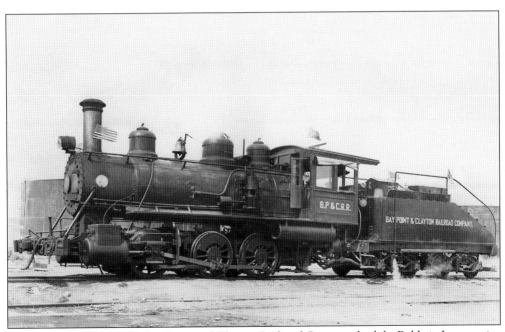

Pictured is a train from the Bay Point and Clayton Railroad Company built by Baldwin Locomotive Works in 1907 with a total weight of 108,000 pounds.

Harry Keller (left) and Frank Foskett are shown on the west end of Salvio Street around 1910. They were partners in the butcher business. Harry Keller became a rancher in Clayton, and Frank Foskett was one of the founders of the First National Bank of Concord.

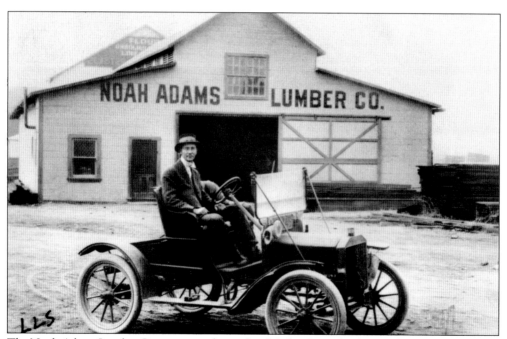

The Noah Adams Lumber Company was located on Market Street by the Southern Pacific railroad tracks. Noah Adams owned one of the first automobiles in Concord.

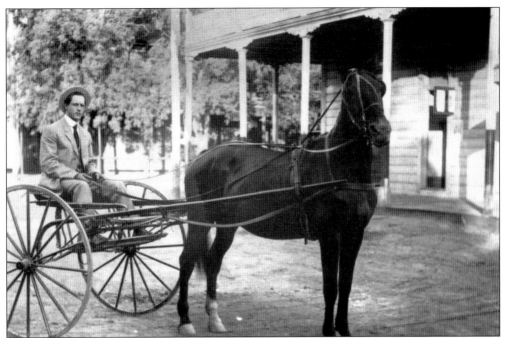

Lawrence V. Perry was Concord's premier builder and contractor. He is pictured here at the corner of Galindo and Salvio Streets around 1910. The L. V. Perry Construction Company built commercial and school buildings as well as many of the larger homes in Concord, some of which are now landmarks, including the Perry, Bibber, Foskett, and Vasconi homes.

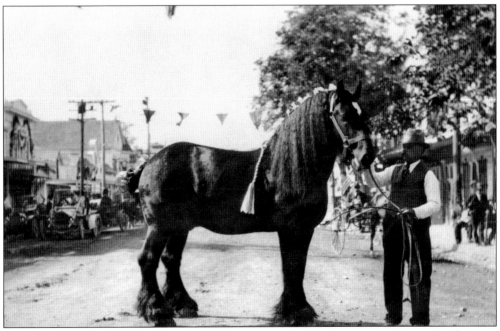

Joe Williams and his stud stand on Salvio Street around 1910. Joe was on the board of directors of the Bank of Concord with other prominent citizens.

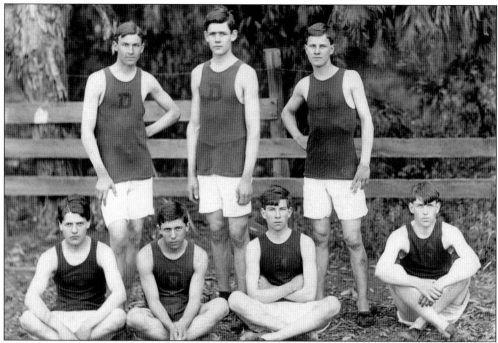

The Mount Diablo High School men's track team in 1909 included, from left to right, (seated) Wayman Ballenger, George Soares, Martin Gavin, and Herb Chapman; (standing) Harvey Sellers, Van Neff, and Arlo Sperry.

Sitting in front of the Perry House on Clayton Road by the railroad crossing are, from left to right, Clyde Humphrey, Farmer Boyd, Althea Boyd, Stanley Williams, Beverly Thissel, Marian Smith, Harold Galindo, Flossie Humphrey, and Gladys Williams.

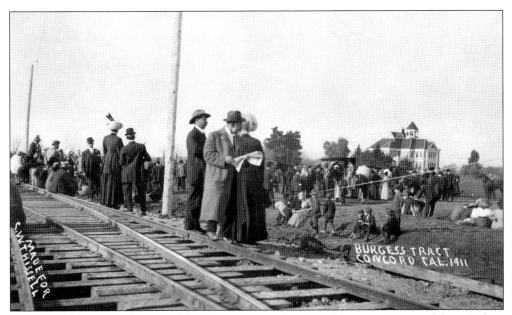

In 1910, Robert Noble Burgess of San Francisco purchased 3,700 acres in Concord from Foskett and Elworthy on Willow Pass Road. The land was subdivided and on March 11, 1911, the Burgess Tract opened for sale. The Concord Grammar School stands in the background.

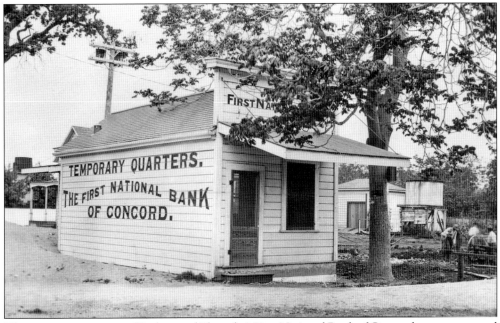

The temporary quarters of Foskett and Elworthy's First National Bank of Concord was constructed in 1910 at the corner of Salvio and Galindo Streets. A permanent building at the same location was completed in 1911 and was called the Foskett and Elworthy Building.

Frank W. Foskett arrived in Concord with his wife, Alice, and established the Concord Meat Market. They had four children: Clifford, Ethel, Walter, and Raymond. In 1905, Frank became the first city treasurer of Concord. In 1911, he and his partner, Herbert H. Elworthy, built the Foskett and Elworthy Building. The Fosketts owned a 4,000-acre ranch in what are now Port Chicago and Clyde.

Born in England and raised in Canada, Herbert H. Elworthy lived in Black Diamond, Clayton, and Nortonville before moving to Concord as a partner with Frank Foskett in the renamed Foskett and Elworthy Meat Market. Herbert was a rancher and banker and served on the school board. He later became president of the First National Bank of Concord and the second mayor of Concord.

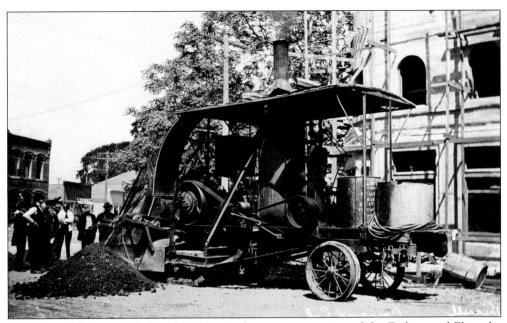

Frank W. Foskett and Herbert H. Elworthy began construction of the Foskett and Elworthy Building in 1911. It was located on the corner of Salvio and Galindo Streets, near Lambert's Bakery, which stands in the background on the left.

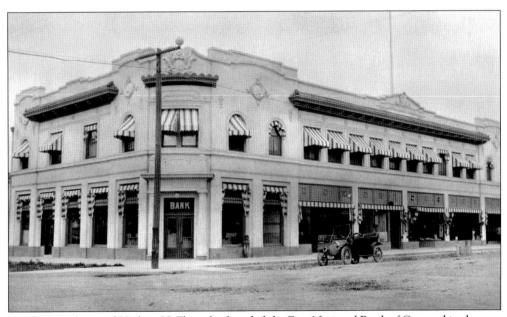

Frank W. Foskett and Herbert H. Elworthy founded the First National Bank of Concord in the new Foskett and Elworthy Building. Foskett was president, Elworthy was vice president, and Foskett's son Clifford was an assistant cashier. Elworthy became president when Foskett died in 1919.

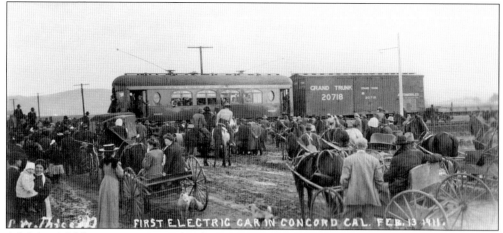

Adolphus Maltby was instrumental in bringing the electric railway to Concord. He donated land at East Street and Clayton Road for the railway station and granted a right-of-way through his property for the tracks. On February 13, 1911, the first electric train arrived in Concord from Bay Point.

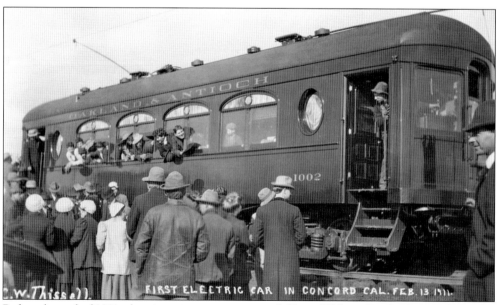

Before the end of 1911, electric train service was available in Walnut Creek. A tunnel was dug through the Oakland hills, and service to Oakland was added on August 5, 1913. The line was known as the Oakland and Antioch Railway until 1927, when it became part of the Sacramento Northern Railway.

OAKLAND AND ANTIOCH RAILWAY

TIME CARD
LOCAL AND IN CONNECTION WITH SANTA FE RY.

Effective May 28, 1911

NORTH BOUND.

STATION	No.2 A.M.	No.4 A.M.	No.6 A.M.	No.8 P.M.	*No.10 P.M.	No.12 P.M.	No.14 P.M.	No.16 P.M.
Lv. Walnut Creek	5:45	8:24	10:05	12:15	1:57	4:11	8:06	9:35
Lv. Moore		8:44			2:17	4:31		
Lv. Meinert Junction	5:58	8:51	10:18	12:28	2:24	4:38	8:19	9:48
Lv. Concord	6:05	8:58	10:25	12:35	2:31	4:45	8:26	9:55
Arr. Bay Point	6:18	9:12	10:39	12:49	2:45	4:59	8:40	
Lv. Bay Point	6:23	9:17		12:54		5:05	8:45	
Arr. Richmond	7:19	10:20		1:50		6:05	9:40	
Arr. Berkeley	7:43	10:43		2:08		6:23	9:58	
Arr. Oakland	7:50	10:50		2:15		6:30	10:05	
Arr. San Francisco ..	8:20	11:10		2:45		7:00	10:30	
Lv. Bay Point......			10:45		3:47	5:47	8:45	
Arr. Antioch			11:06		4:08	6:07	9:08	
Arr. Stockton			12:05		5:10	7:10	10:15	
Arr. Sacr. over C. C. T. Co. Lines..			3:37 P.M.		8:40			

SOUTH BOUND.

STATION	No.1 A.M.	No.3 A.M.	No.5 A.M.	No.7 A.M.	No.9 A.M.	No.11 P.M.	No.13 P.M.	No.15 P.M.
Lv San Francisco...			7:00	9:00		4:00	6:45	
Lv. Oakland			6:50	9:20		4:20	6:40	
Lv. Berkeley			6:57	9:26		4:26	6:46	
Lv. Richmond			7:55	9:55		4:54	7:45	
Arr. Bay Point			8:48	10:45		5:47	8:45	
Lv. Stockton		5:00	8:00		11:35 P.M.	3:45	7:35	
Lv. Antioch		6:00	8:56		12:33	4:43	8:29	
Arr. Bay Point		6:23	9:17		12:54	5:05	8:45	
Lv. Bay Point		7:15	9:22	10:51	1:00	3:06	6:02	8:50
Arr. Concord	5:20	7:29	9:36	11:05	1:14	3:20	6:15	9:04
Arr. Meinert Junction	5:27	7:36	9:43	11:12	1:21	3:27	6:22	9:11
Arr. Moore					1:28	3:34	6:29	
Arr. Walnut Creek..	5:40	7:49	9:55	11:25	1:47	3:54	6:49	9:24

* Train No. 10 connects at Bay Point with S. P. train for Martinez, Oakland and San Francisco.

L. R. RICHARDS, Agt. BAY POINT	H. H. FULTON, Agt. CONCORD	G. R. HAMLETT, Agt. WALNUT CREEK

R. H. FISH, Traffic Manager, Concord.

O&A Timetable No. 2, effective May 28, 1911, Showing service between Bay Point and Walnut Creek, together with connecting Santa Fe trains at Bay Point to and from San Francisco and Stockton.

The O&A station "Moore" (later renamed "Gavin") was the terminus of the Walwood Branch which left the O&A main line at Meinert Jct.

---TRB Collection

The Oakland and Antioch Railway schedule effective May 28, 1911, included stops in Walnut Creek, Moore/Gavin, Meinert Junction (on the Walnut Creek/Concord border), Concord, and Bay Point, with connecting Santa Fe trains at Bay Point to Richmond, Berkeley, Oakland, San Francisco, Antioch, Stockton, and Sacramento. The Concord agent in 1911 was H. H. Fulton.

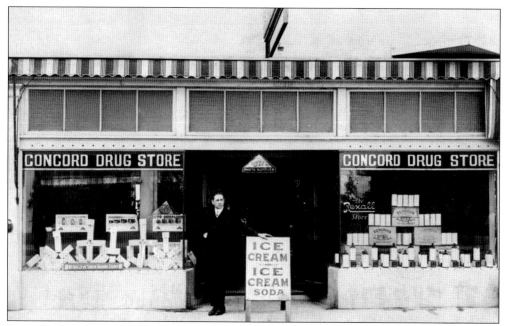

Retired U.S. Navy captain J. J. January purchased the Concord Drug Store from Randall H. Latimer, who had operated it on Main/Salvio Street since 1879. January enlarged and incorporated his newly acquired store in 1907. At the southeast corner of Salvio and Galindo Streets, J. J. January stands in front of the store in 1912. January operated the drugstore on this site until 1919, when he sold it to Dr. Frank Eidenmuller.

George Keller was an assistant to J. J. January at the Concord Drug Store and became the very successful owner a chain of local drugstores. Here Mr. and Mrs. George Keller sit in the front of their Buick touring car with Mr. and Mrs. Croxon in the rear.

The Walnut Carnival was a major event in Concord. In 1912, a Ferris wheel was set up on Mount Diablo Street.

Marjory Matheson rides her trained cow during the 1912 Walnut Carnival. She sits in front of the Concord Hotel at the corner of Salvio and Mount Diablo Streets. Marjorie was also known to ride her cow to school.

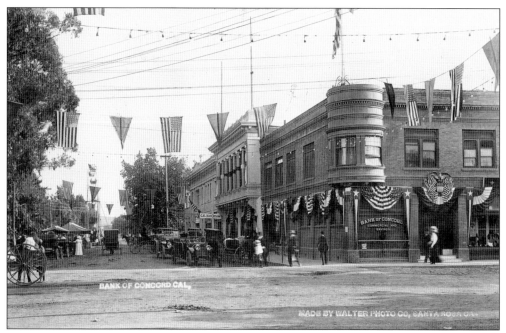

Melvin E. Lyon grew up as a farmer in Iowa and worked for the local mortgage company. In 1899, his uncle gave him $20,000 to start a business. Melvin traveled to California to find a likely spot, and when he arrived in Concord, he found a town ripe for its first bank. He founded the Bank of Concord in 1900 and opened for business on January 2, 1901.

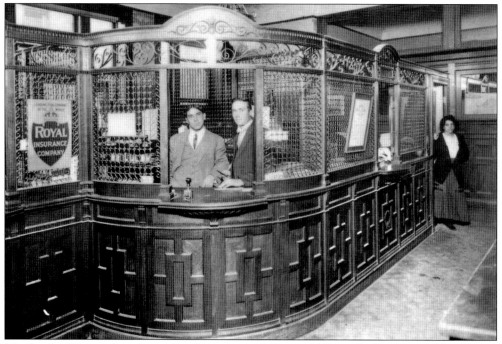

The Bank of Concord was located at the corner of Salvio and Mount Diablo Streets. The interior was paneled in mahogany. A ceiling painting was added later that required the artist to lie on his back on scaffolding like Michelangelo.

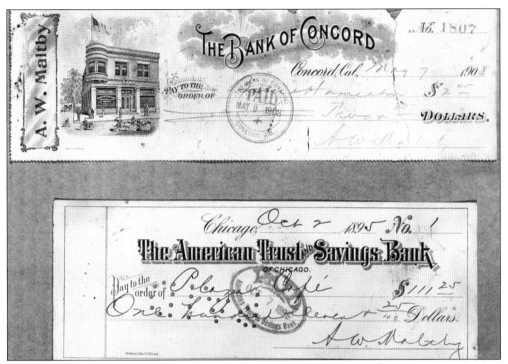

This Bank of Concord check printed for wealthy rancher and former Chicago native Adolphus William Maltby is dated May 7, 1908.

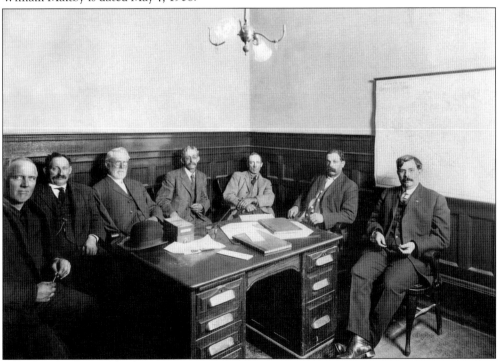

The members of the board of directors of the Bank of Concord are pictured from left to right: Joseph Boyd, Lars Elsen, J. F. Busey, ? Munson, George Whitman, Joe Williams, and Melvin E. Lyon.

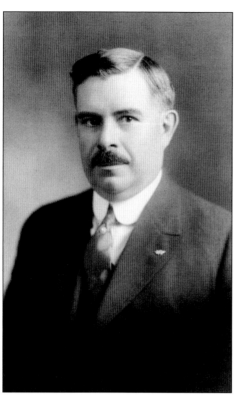

Melvin E. Lyon, pictured in 1900, served on Concord's first board of trustees and was treasurer of the Concord Chamber of Commerce when it was formed in 1910. In 1913, he married Edna Alice Early of Berkeley, and they had one daughter.

In 1915, Melvin and Edna Lyon attended the World's Fair. Edna died in 1930, and Melvin later married her sister, Florence Early Allen, who taught first through eighth grades at the one-room Oak Grove School on Ygnacio Valley Road.

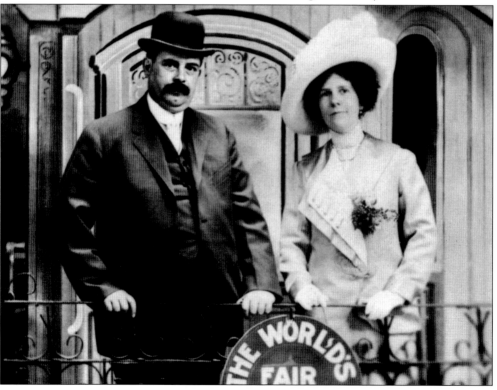

The Concord French Laundry was established by George and Erma Narberes in 1913. It was located on the corner of Willow Pass Road and Grant Street. Their horse-drawn laundry wagon was a common sight around town. George's sons Louis Narberes and Rene Narberes and their families continued the business after George died and ran the business until 1970.

Four men stand in front of the Vargus Saloon on "the day it snowed in Concord," January 9, 1913. The saloon was located on the corner of Grant Street and Willow Pass Road where Wells Fargo Bank is now located. The next owner of the saloon renamed it Bucket of Blood after the San Francisco saloon famous for having a murder every night.

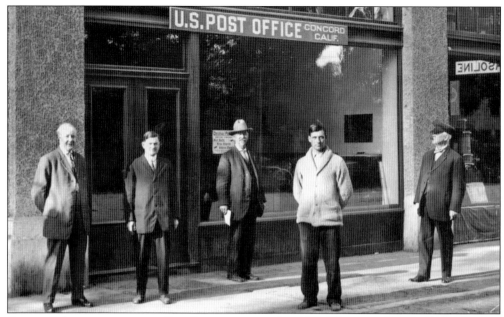

Concord's first postmaster was Sam Bacon, appointed in 1872. The post office was located in his store. Postmaster Presentation M. Soto relocated the post office in his home. Later the post office was moved to a more "official" location in the Concord Inn Building, where standing from left to right are postmaster Charles Guy, Concord's first letter carrier Robert "Bob" Henderson Berwick in the light sweater, and Ed Slattery.

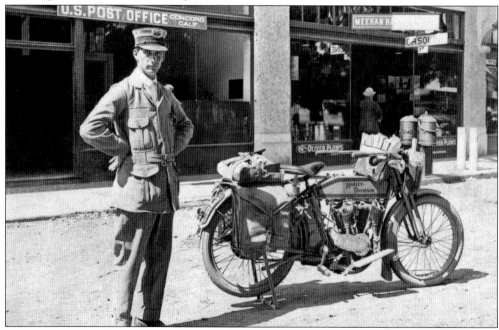

Letter carrier Bob Berwick stands with his Harley-Davidson mail delivery motorcycle. The post office was destroyed in the 1917 fire, but postmaster Guy was able to save the records and safe. The post office remained at the same site in the newly built M. E. Lyon Building, where it remained until 1944.

When the town of Todos Santos was laid out in 1868, the center was dedicated as a park by Salvio Pacheco to the people of the town. Todos Santos Plaza became a central gathering place for community celebrations. The plaza was also called Concord Plaza.

In 1903, two large cannons from the battleship USS *Independence* were put on display in Todos Santos Plaza. They were obtained by former justice of the peace John J. Burke. Ernfrid Mattson sits on a cannon on July 4, 1913. The cannons mysteriously disappeared years later.

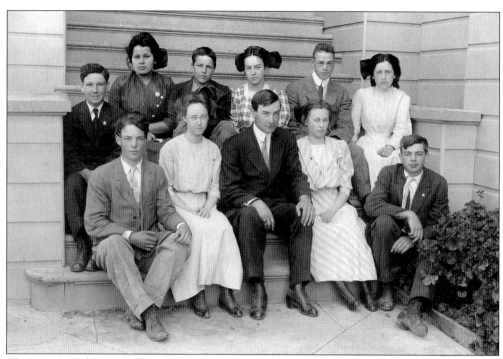

The Mount Diablo High School class of 1913 included, from left to right, (first row) Curtis Beach, Ruth Boyd, Roy Bibber, Nell Grant, and Ralph West; (second row) Elwin Williams, Elizabeth Williams, unidentified, Edith Leh, Ray Foskett, and Carmen Arreghi.

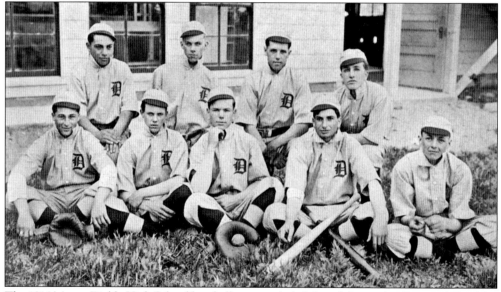

The 1914 Mount Diablo High School baseball team included, from left to right, (first row) Franklin Freitas, John Graves, Mark Elworthy, George Murchio, and Justin Randall; (second row) Prosper Olivera (captain), Lemuel Dunn, Alfred Noia, and Clifford Thomson. The season started with great enthusiasm with new uniforms donated by the trustees and the student body. San Ramon Valley High forfeited to them on May 2, and they beat Liberty High in Brentwood 5-3 on May 9—George Murchio claimed 22 strikeouts that day.

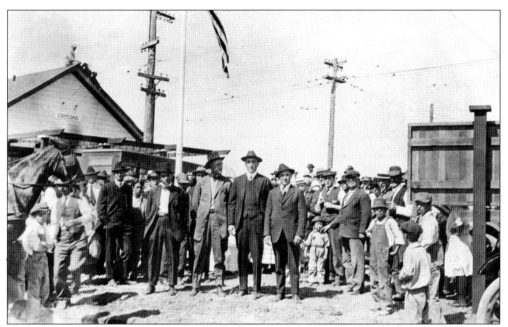

Shown here are four Concord boys off to the army at the Sacramento Northern railroad station at East Street and Clayton Road around 1914. Pictured centrally are, from left to right, Calvin McKean, Jerry Ough, Joe Fisher, Caesar DeBenedetti, and Jim McCuen.

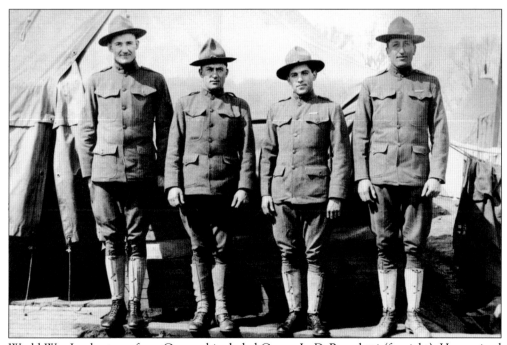

World War I volunteers from Concord included Caesar L. DeBenedetti (far right). He survived the war and operated a pool room on Salvio Street that was destroyed in the fire of 1917. He later became postmaster of Concord.

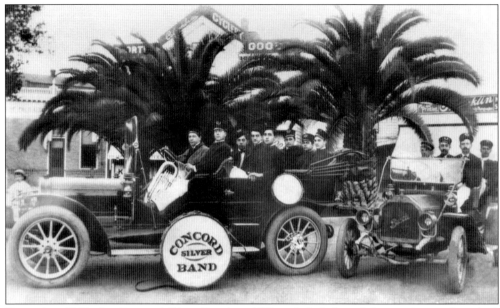

Formed in 1905, the Concord Silver Band in 1912 included, from left to right, unidentified, Laurian Perry, unidentified, Al Vargas, Louis Mangini, Alex Matheson, two unidentified, Herb Durham, Charles Pacheco, Antonio Vasconi, and Robert Matheson.

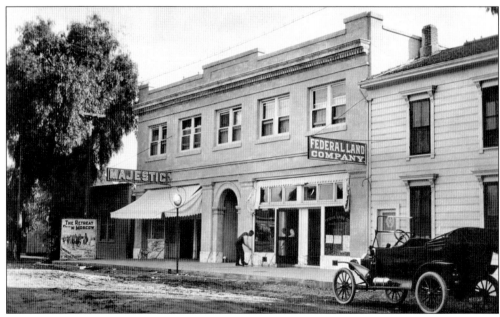

Joseph DeRosa's Majestic Theatre was built on the east side of Mount Diablo Street in 1914 as an addition to his Concord Hotel. It was a huge improvement over the makeshift movie hall upstairs in his hotel. The grand opening of the theater featured Norma Finney on the piano.

Frederick Galindo married Catherine Briones in 1907. From 1912 to 1916, he served as Concord city trustee. This picture of the Galindo family, taken around 1920, includes, from left to right, Ruth Galindo, Catherine Galindo, Harold Galindo, Leonora Galindo, and Frederick Galindo. Frederick was city treasurer from 1932 to 1943 and was succeeded by his wife, Catherine, who served for nearly 20 years.

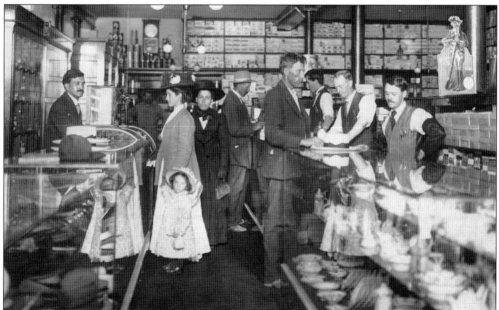

Frederick Galindo was the co-owner and manager of the largest store in town, the Concord Mercantile Company on Salvio Street. In this c. 1915 photograph, Frederick Galindo (left) waits on customers, and Ed Slattery (center right) assists other shoppers. In 1917, the mercantile was destroyed by fire. After the fire, Frederick went to work at the Concord Department Store, where he had previously worked when it was known as the Randall Brothers Store.

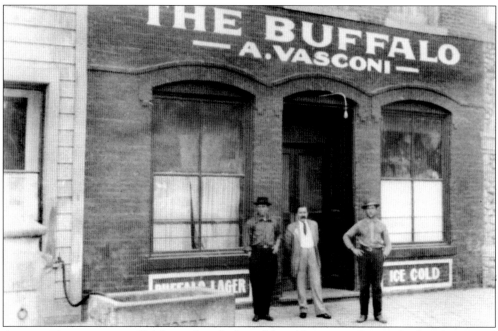

Antonio Vasconi came to California from Italy and found his way to Concord, where he opened a grocery store on Galindo Street around 1908. In 1915, he purchased Lambert's Bakery and the Buffalo Saloon on Concord Avenue between Salvio and Galindo Streets. The Buffalo Saloon later became the Playtime Club.

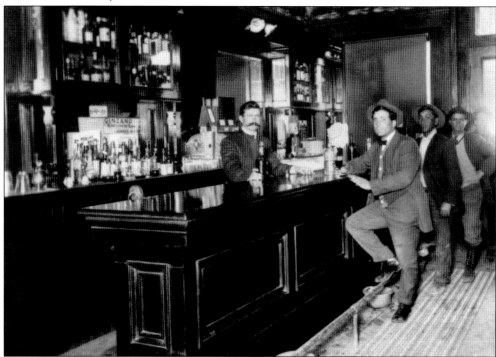

The Fan Saloon was located on Salvio Street between Mount Diablo and Galindo Streets. This picture was taken around 1915.

The Gehringer family was among Concord's early pioneers. Andrew Gehringer immigrated to the United States from Germany at the age of 21 and joined the army. He was based at the Presidio in San Francisco, and his duties included delivering horses and cattle to Sacramento, passing through the Rancho Monte del Diablo on his way. After leaving the army, he began farming in Santa Clara with John Denkinger. They bought adjoining ranches from Don Salvio Pacheco in the early 1860s. Andrew Gehringer sits on a buggy in front of his home on Denkinger Road with his son Andrew Conrad Gehringer, son-in-law John N. Denkinger, and his daughter Marie Gehringer.

In 1915, the Gehringer family visited the Pan-Pacific International Exhibition. Pictured here are Andrew Gehringer with his wife, Marie Denkinger Gehringer, and three of their five children, Elaine Gehringer, Norbert Gehringer, and Hilda Gehringer.

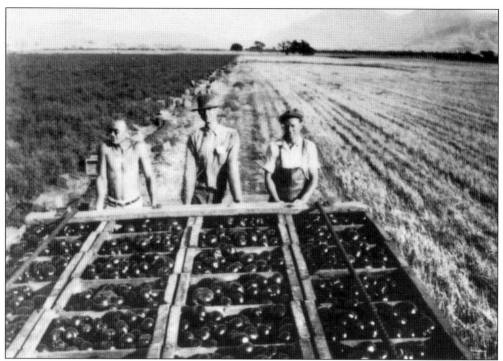

Andrew Gehringer's son Norbert is pictured supervising tomato picking on the Gehringer Ranch in 1931. Pictured from left to right are Jack MacArthur, Norbert Gehringer, and a farmhand.

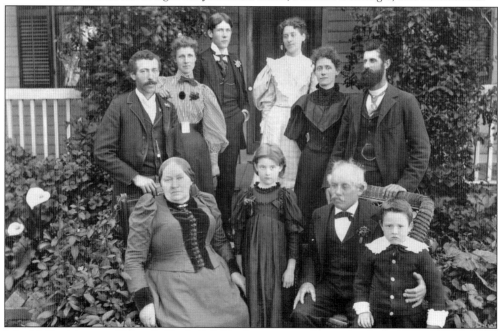

John N. Denkinger and his wife, Emily Bolz Denkinger, owned a ranch adjacent to the Gehringers. Much of the land that comprised the Gehringer and Denkinger ranches was appropriated by the government in 1940 for the naval weapons station. Emily Bolz Denkinger sits front left, with John N. Denkinger seated front right, surrounded by their family.

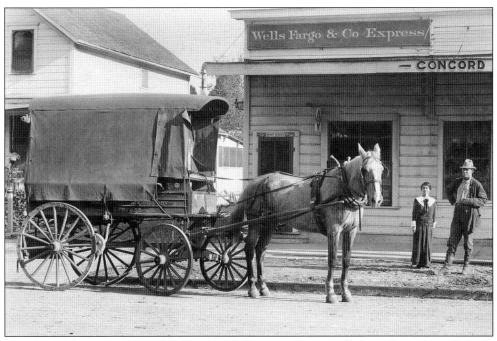

The Concord station of the Wells Fargo and Company Express office was located on Galindo Street. Newton Williams drove the Wells Fargo Express wagon. This image taken in front of the station was made into a postcard around 1916.

A Wells Fargo and Company Express receipt for $36 dated August 13, 1897, at Concord to Rosa Bisso is shown here signed by J. J. January. The receipt advertises 36,000 miles of lines through the United States and territories, British Columbia, and Mexico, and forwarding to Liverpool, London, Le Havre, Paris, Hamburg, and all the principal ports in Europe by steamers from San Francisco.

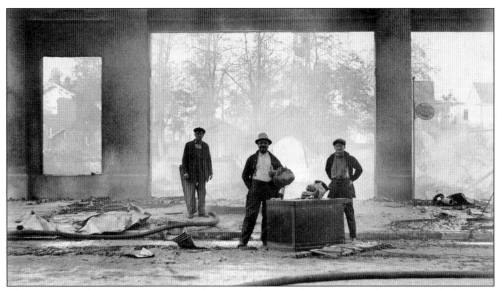

The fire of April 25, 1917, was Concord's greatest disaster, destroying much of Concord's business district, including Frederick Galindo's Concord Mercantile Company, the Concord Inn building, the post office, Meehan's Hardware Store, the Bank of Concord, and Barney Neustaedter's Pioneer Store. Apparently the fire started behind the Concord Inn early in the morning, and although quickly summoned from the fire house less than a block away, the Concord Fire Department was unable to put out the fire; fire departments from around the county and Oakland rushed to their aid.

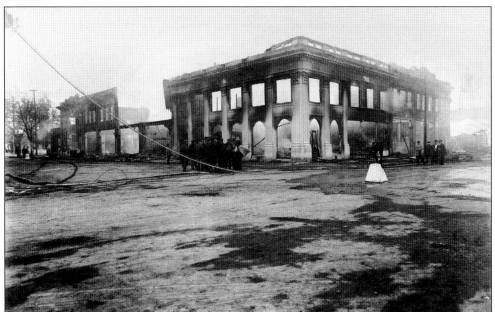

People staying at the Concord Inn lost all of their possessions, including owner Melvin E. Lyon and his family, manager D. H. Chambers, and several schoolteachers. Concord Inn clerk Guy Berger led the firemen to rescue two trapped employees. Nobody died in the fire. As the fire spread, the community worked feverishly to save the contents of businesses, banks, and the post office. The fire claimed two entire blocks of downtown Concord except for one building and one home.

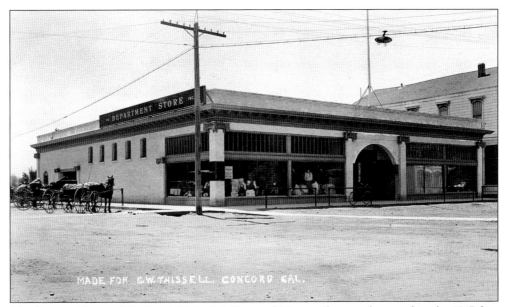

The Concord Inn and Frederick Galindo's Concord Mercantile were destroyed in the 1917 fire. They were replaced in 1918 by the Randall building, which housed the Concord Department Store, managed by Frederick Galindo.

Concord's first city library consisted of 62 donated books in a room of the Fireman's Hall building in 1906. Concord's first library building was constructed in 1917 with funds from the Andrew Carnegie Foundation. The library was located in Todos Santos Plaza and operated until 1958.

Hubert Howe Bancroft bought land near Concord as vacation property. He built a log cabin, a Swiss chalet, and an Asian-style home on the property. H. H. Bancroft was the donor of the Bancroft Library at U.C. Berkeley. His grandson Philip Bancroft Jr. grew walnuts and pears on the property.

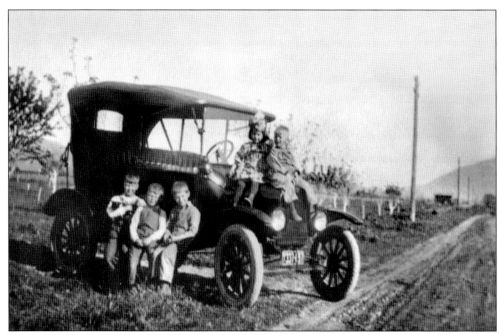

In 1918, Wilheim and Anna Sattler moved with their three sons to a 14-acre ranch at the current intersection of Clayton Way and Concord Boulevard. The three boys, Ernie, Hank, and Bill Sattler, are pictured here. The three brothers would later turn William Eddy's Garage on Willow Pass Road into Sattler's Appliance Store.

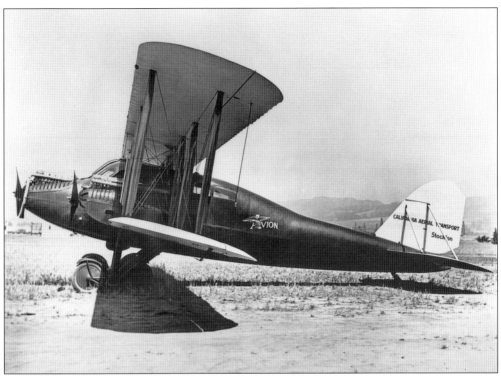

This California Aerial Transport Curtiss Eagle airplane used Concord's Mahoney Field in the early 1920s. The service made a regular run between Concord and Burbank in Southern California.

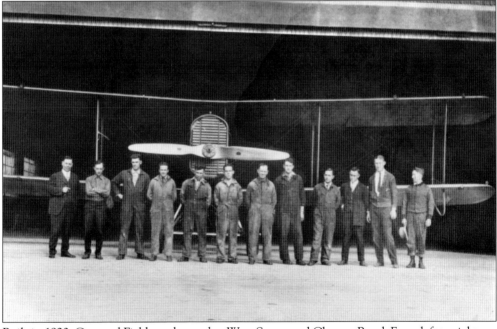

Built in 1923, Concord Field was located at West Street and Clayton Road. From left to right are Egge, Kidd, Jensen, Vance, Razor, Ferry, Smith, Carr, Weaver, Kinney, Bush, and, at far right, aircraft mechanic John Jackson.

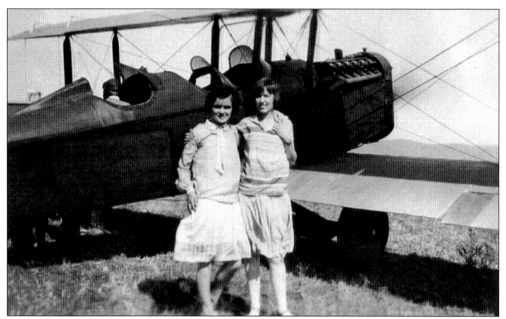

In 1925, mail operations began at Concord Field, which became known as the Concord Airmail Airport. The government called the field the Concord Transcontinental Terminus. Kathryn Randall stands to the left of a friend as they pose in front of a rare three-seat airplane. The first coast-to-coast commercial passenger flight departed from Concord on September 1, 1927, and landed in New York 32 hours later.

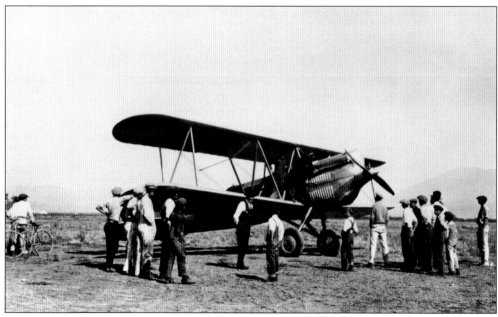

Visitor's Day at Concord Airmail Airport is shown here in 1928. Located at West Street and Clayton Road, runways were added to the airport in the area that is now Concord High School. A new Boeing Model 40B airplane is on display. Mail operations at Concord Field continued until 1933, when the Oakland Airport was opened. Concord Field was officially closed in 1950.

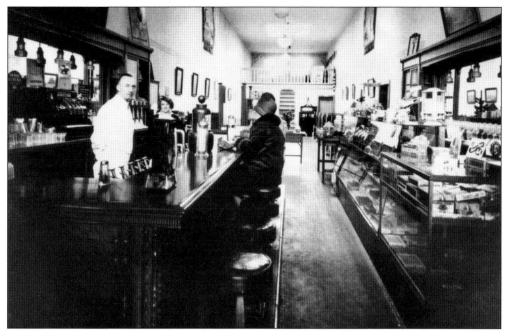

A favorite hangout for Mount Diablo High School students was Willy's Fountain, which was located inside Williamson's Ice Cream Parlor in the 1920s. Willy stands behind the counter. His wife, Mae, and daughter Wilma worked with him at the fountain, which was located on Salvio Street facing Todos Santos Plaza.

Dr. Henry Stirewalt, a retired doctor from the Bay Area, came to Concord in 1920 and soon gained a reputation by offering his services for free to the poor. He was a cofounder of Concord Hospital in 1930 with his nurse, Edna Hayward. The new hospital was located on East Street, which continues to be the location of Concord's hospital.

Son of Spanish pioneers Silveria and Carmen Soto, Presentation "Present" M. Soto served as postmaster of Concord for 26 years. He was elected the sixth mayor of Concord in 1922.

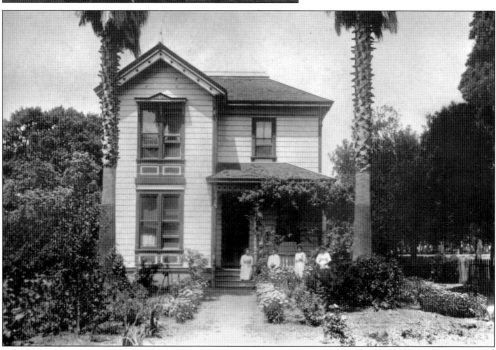

The Soto family purchased the Webb house, which was located at the corner of Bonifacio and Mount Diablo Streets. The Webb-Soto house became a landmark in 1976. Pictured on the left are Presentation and Martha Soto with their daughters Elma, Evelyn, and Florence on the right.

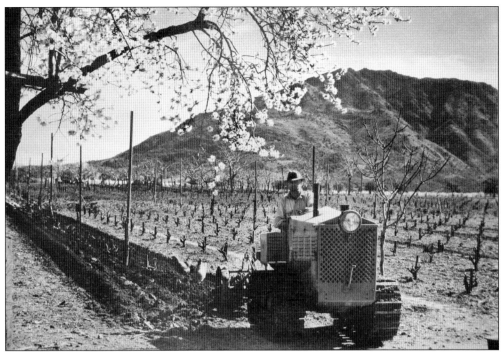

Giovani Angelo Curletto came to Concord from Italy in 1924. He farmed walnuts and almonds on his 40-acre Curletto Farms orchard between Clayton Road and Pine Hollow, heading east starting at El Camino. They had an unobstructed view of Mount Diablo through Clayton. (Courtesy of Stella Curletto.)

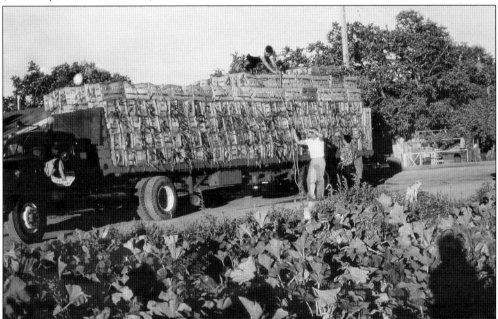

The Curletto family moved to another 40-acre farm in 1941 off Bailey Road. John Curletto supervises corn tie-down on a Catamatori truck in front of the Bailey ranch house as his son Johnny and dog Buck watch. (Courtesy of Stella Curletto.)

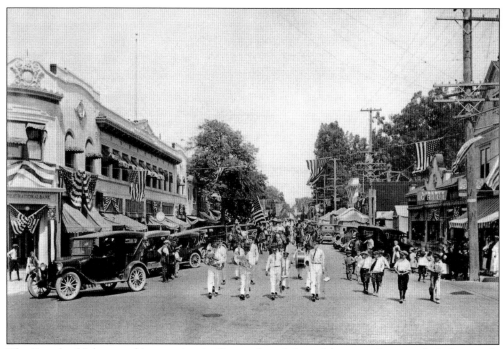

The Fourth of July was a big occasion in Concord, and the celebration always included a parade and other events such as dances, carnivals, circuses, and even exploding anvils. Here the Fourth of July parade makes its way down Salvio Street in the mid-1920s.

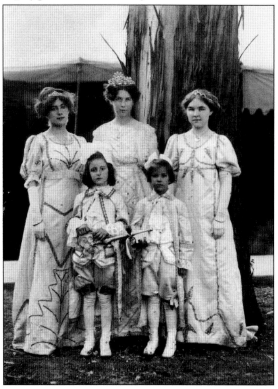

Women and children are shown dressed for a Fourth of July parade in the 1920s at Todos Santos Plaza. The children are Rose Vasconi Belka on the left and Ruth Dunn Beck. Eileen Lambert stands in the center behind them.

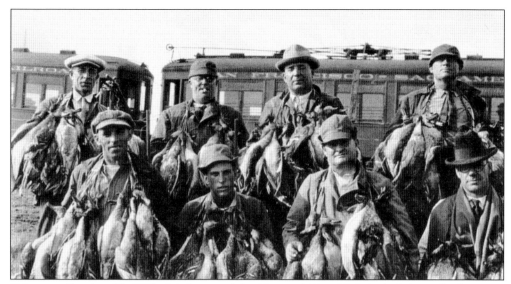

Taken on October 18, 1925, this image of the Concord Gun Club included, on the first row, Charles Guy, Walter Lewis, and two unidentified men; and, from left to right on the second row, Paul L. Keller, Bill Eddy, George Soares, and Jack Atchison.

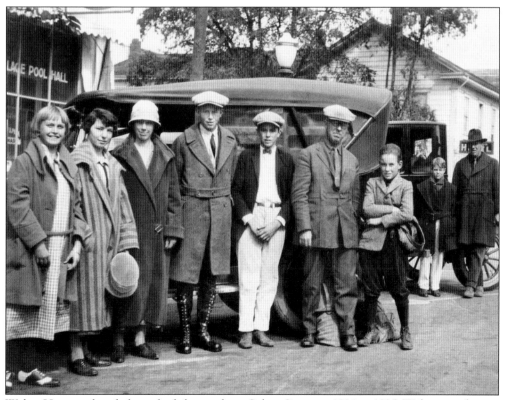

Walter Hansen, fourth from the left, stands on Salvio Street in 1924 or 1925. Walter was the son of John Hansen, who built many of the structures in downtown, including the firehouse and the Veteran's Memorial Building.

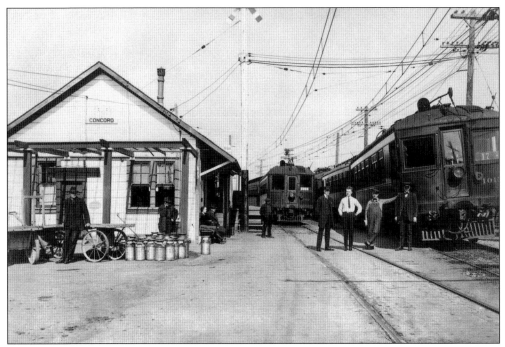

Shown here is the Concord Sacramento Northern railroad station at Clayton Road and East Street in the 1920s. Standing on the right in front of the train are brakeman ? Ross, motorman Charles Holmes, station agent George Scheuer, and conductor ? Moore. Wells Fargo express agent Newton Williams leans on a wagon at the far left.

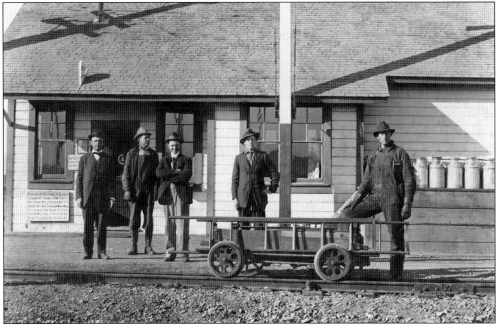

Western Pacific Railroad operated the Concord Sacramento Northern Railroad from 1927, when it purchased both the Oakland and Antioch Railway and the Southern Pacific lines for $1.2 million. Local train service continued in Concord until 1941.

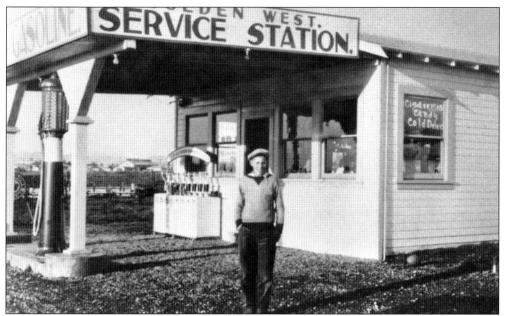

Lewis Ervin Lehmer and Essie Lehmer moved to Concord in 1926 with their children, Lewis Ervin Jr., Doris, Marian, and Clyde. Lewis was a railroad and telegraph agent for the Southern Pacific Railroad, and they lived above the railroad station on Salvio Street near Market Street. In 1927, the Lehmer family purchased a third of an acre on Cowell Road and opened the Golden West Service Station. Lewis Ervin Lehmer Jr. stands in front of the station in this picture.

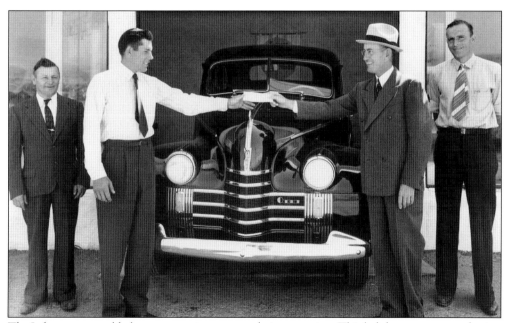

The Lehmers soon added an auto repair garage to their gas station. This led them to start purchasing used cars to repair and resell. By 1940, Lewis and Lewis Jr. owned an Oldsmobile dealership. In this photograph, they stand with a new Oldsmobile, flanked by Buck Buchanan, district Oldsmobile representative, and salesman Herb Renfree.

Kumetaro Tamori arrived from Japan in 1901 and earned enough money as a laborer to become a sharecropper. In 1925, he purchased 10 acres of land on Treat Lane in the names of his sons Kumeo and Shoji. Tamori then donated 2 acres of his land for a permanent Japanese community center for Japanese families scattered throughout the East Bay. Thirteen families built a small meeting house and formed the Japanese Concord Institute in 1926. Pictured here from left to right are Sabuki, Kumeo, Shoji, Hideo, Rowena, and George Tamori.

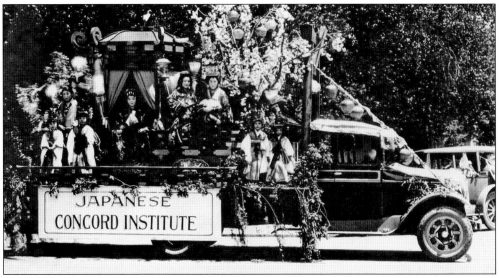

Each year, the Japanese Concord Institute entered an elaborate float in the Pow Wow Parade and presented a Japanese-American Summer Festival, which continues today. The Tamori family built four homes on the Treat property for their next generations. Pictured here is the Japanese Concord Institute parade float from a late-1920s Redman Pow Wow Parade.

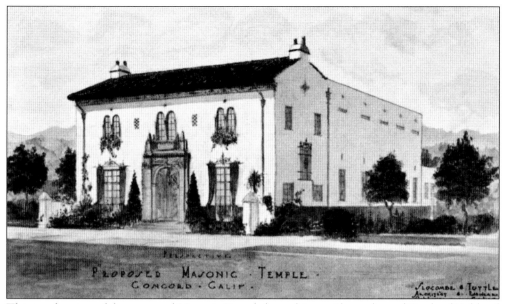

This is a drawing of the proposed Masonic Temple by architects Slocombe and Tuttle of Oakland from 1927.

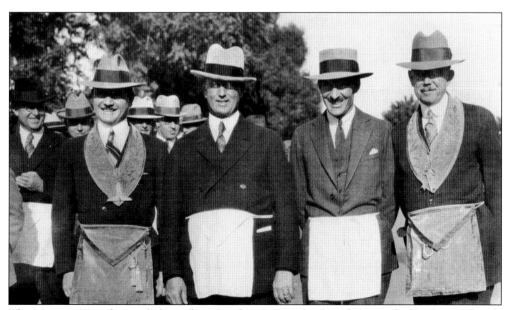

The Masonic Temple was dedicated on October 6, 1928, by, from left to right, Dr. Louis Martin, DDS; L. V. Perry, the builder; ? Hawkes, a garage owner; and A. J. Donnelly, the druggist at Concord Drug Store.

Ruth Galindo, the eldest daughter of Frederick Galindo, was a Spanish teacher at Mount Diablo Union High School. She specialized in teaching the language and culture of Spain and was chairwoman of the language department. Ruth was a charter member of the Concord Historical Society and served as its president. She lived in the Galindo house until her death in 1999.

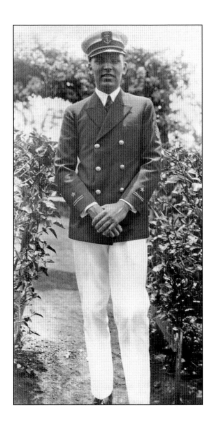

Harold Galindo was the oldest child of Frederick Galindo. He worked for an oil company before entering the navy in 1941 and for Chevron after the war. His younger sister Leonora was an author of local and family histories and editor of the *Contra Costa Chronicles*.

Five

THE DEPRESSION YEARS
AND WORLD WAR II

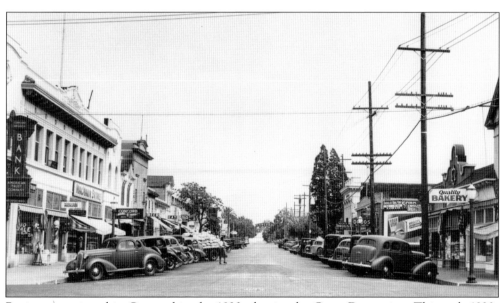

Business continued in Concord in the 1930s despite the Great Depression. This early-1930s photograph shows Salvio Street looking east, where very few businesses closed compared to other cities in Contra Costa County.

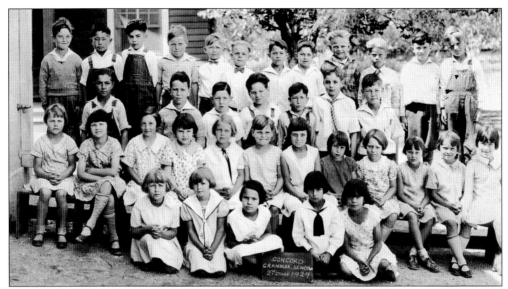

Pictured is the 1929 Concord Grammar School second-grade class. Shown from left to right are (first row) Berniece Tyner, Virginia Williams, Olga Carzino, Mary Alameda, and unidentified; (second row) Helen Evans, Celia Cross, Wilma Williamson, Beth Keller, unidentified, Betty Kenerly, Louise Brunelle, two unidentified, Jean Helmke, Sarah Lefker, and Betty Voice; (third row) two unidentified, Gilbert Machado, Kenneth Gomez, unidentified, Larry Andrade, and George Hill; (fourth row) Bill McKinnon, unidentified, Gerald Davila, two unidentified, Claude Rice, Boyd Ballinger, Bill Hammet, Lyman Glasgow, Donald Quintin, Bob Skinner, and Joe Tomlin.

Hula girls pose at the Concord Grammar School in 1930. From left to right are (first row) Mildred Wyatts, Estelle Auston, Lorraine McDonald, Miriam Cross, Verna Vosi, Patricia Cottrell, Mary McCarthy, Lorraine Vosi, Marthella Foskett, Jean Foskett, Mary Sufred, Josephine Amarani, Anna May Bryon, and Norma Ginochio; (second row) Liny Mae Wygal, Irma Vascony, Lois Patterson, Georgiana Seaber, Hazel Wood, Anna Mae Bjork, Hattie Horwell, Eleanor Duarte, Mary Wood, Florence Tatthier, Florence Kineraly, June Stewart, and Mirabelle Curyer; (third row) Lucella Bilings, Catherine Sturkey, Mary Amarani, Marcilla Whitthair, Dona Edwards, Agnes Lee, Pearl Williams, Eleanor Pallaso, Luella Barry, and May Ross.

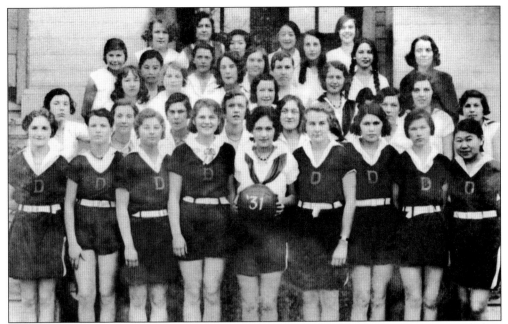

The Mount Diablo High School women's basketball team is shown here in 1931. From left to right are (first row) Holis Matheson, Christina "Gigs" Lombardi, Virginia Scamman, Mary Louise Stevens, Redda Costa (the team's manager), Maxine Scamman, Ella-belle Beringer, Claire McKinnion, and C. Sacamoto; (second row) Kathleen Good, Theona Garrett, Dohrs Kennerley, Wilma Benson, Velda Mattson, and Mary Wood; (third row) Anna May "Anner" Bryan, Jean "Jeanie" Foskett, Jeanette Ravizzia, Margaret Dalton, Alice Iverson, Frances Trimingham, and Angela Carzina; (fourth row) Hattie Harwell, Matsuko Yamaguchi, Sonna "Son" Sparrow, Ruth Murrey, Louise "Lou" Garaventa, and Agnes Lee; (fifth row) Violet Black, Rose "Rosie" Belloma, Fusae "Fusy" Ikadi, Mary Hoshi, and Estelle Alston.

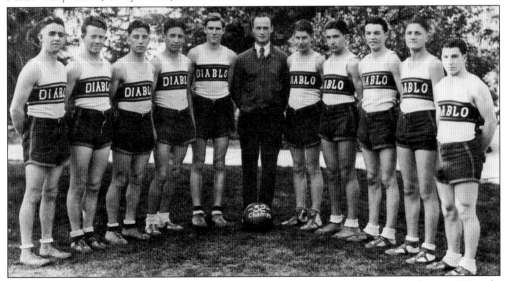

The Mount Diablo High School men's basketball team won the league championship in 1932 with, from left to right, "Skid" Thomas, "Red" Ashlee, Louis Ferriera, Johnny Costa, Milton Westbrook, Peter Kramer, Robert Lee, Bud Frietas, Cliff Woodson, Ed Duarte, and Gilbert Rose.

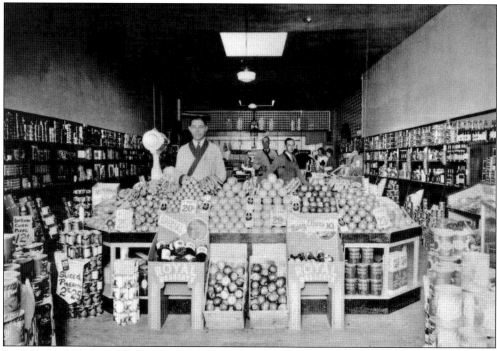

In 1931, Paul Keller sold the meat and grocery departments of his store to Walter E. Lewis and Amador Regalia. The new Lewis and Regalia Market on Mount Diablo Street was the largest store in town. Amador stands in the front of this picture with Walter in the center back.

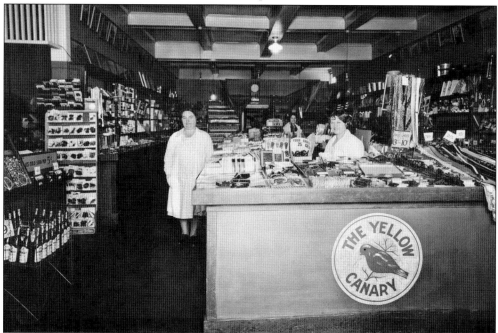

After 1919, Carl Hepp and Rita Potter operated the Yellow Canary Store in the old Concord Drug Store location on Salvio Street. This photograph was taken in 1931. The store later became part of the Ben Franklin 5 and 10¢ store chain, which later became Beede's Variety Store.

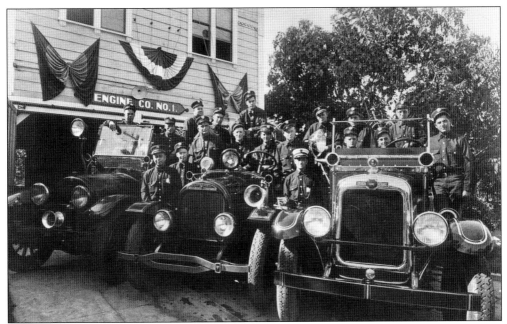

The Concord Engine Company No. 1 building relocated from Mount Diablo Street to Willow Pass Road in 1911 to make room for the Concord Inn. Pictured in 1933, fire chief Allen Vargus wears a white hat in the center. The trucks from left to right are a 1924 Brockway, 1927 Cadillac American La France, and a 1933 Cadillac American La France. The building served as the fire department until 1939, when it became city hall and later the Concord Chamber of Commerce.

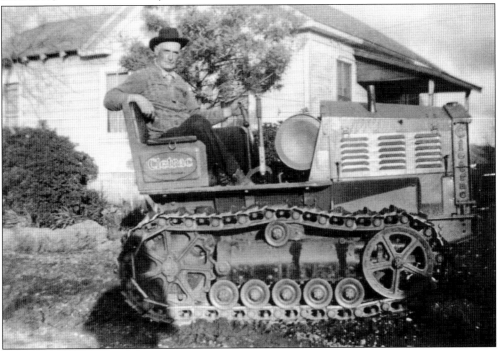

Guiseppe Dianda sits on his Cletrac tractor in front of the Dianda family home on Clayton Road near the intersection of Denkinger Road in this 1933 photograph.

The 1934 Annual Red Men Pow-Wow Parade marches northwest on Salvio Street, passing Tony's Toggery, Williamson's Candy Store, the Concord Hotel, the barbershop, the photography shop, and Joe DeRosa's Coffee Cup Restaurant.

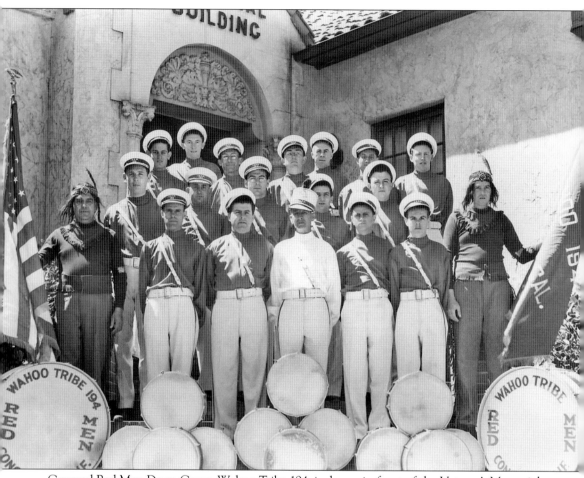

Concord Red Men Drum Corps, Wahoo Tribe 194, is shown in front of the Veteran's Memorial Building (then called the American Legion Hall) on the southwest corner of Colfax Street and Willow Pass Road. From left to right are (first row) Steve Lee, Elmer Mortenson, Harold Rodoni, Claude Rice Sr., John Bagnaschi, Claude Rice Jr., and George Sanko; (second row) Clyde Mitchell, John Devincenzi, Chester Brunelle, John O'Dello, and Walter McAtee; (third row) Joe Santos, Victor Lavignino, Frank Devincenzi, Pete Bacciglieri, Charles Enos, Louis Bisso, and Albert Trette.

The Enean Theatre was built in 1937 on Grant Street between Willow Pass Road and Salvio Street across from Todos Santos Plaza. This 1938 photograph features the Bing Crosby film *Sing You Sinners*. The theater building included Lavere's Confectionery and Fountain and Piccone's Radio Shop.

Harry and Marie Wentling started their photography business in Concord in 1945. Their sons Gerald F. "Jerry" Wentling and Thomas J. Wentling worked with their parents and continued the business after Harry died. Gerald later opened Wentling's Fine Jewelry in Salvio Pacheco Square and served as the first president of the Concord Historical Society. (Photograph courtesy of Jerry Wentling.)

The trail ride kickoff of a 1940s Concord Horsemen's Parade rides down Salvio Street past the Plaza Hotel.

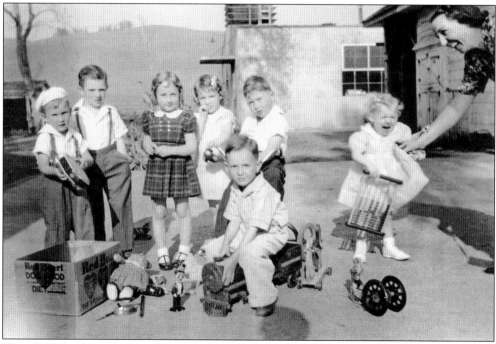

This 1940s birthday party at the Bollman Ranch and Dairy included Jeffrey Nicklas, Marvin McKean, Beverly Bollman, Elinor Olsen, Wesley Aldich, Donald Gillis, Susan Olsen, and Eloise Olsen.

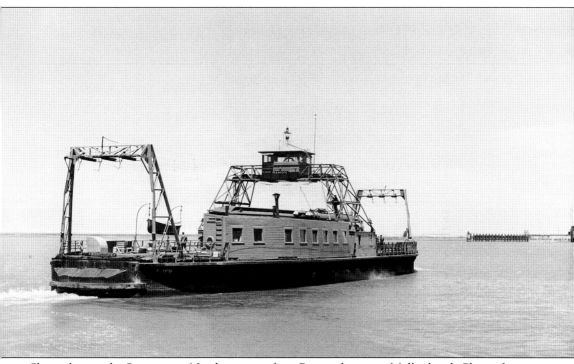

Shown here is the Sacramento Northern train ferry *Ramon* departing Mallard with Chipps ferry slip in the background. Mallard ferry slip is in Contra Costa County; Chipps ferry slip is in Solano County. The Oakland, Antioch, and Eastern Railroad received permission to build a bridge, but it was too costly, so the temporary solution of a train ferry became permanent. The low building on the deck is a lunch-coffee shop, which replaced an inadequate below-deck facility. The entire train crossed the Suisun Bay between Mallard and Chipps. The *Ramon* could handle up to six passenger cars or 10 freight cars. The steel *Ramon* was built in 1914 by Lanteri of Pittsburg to replace a wooden ferry boat that burned in 1914. The *Ramon* was powered by the largest spark-ignition gasoline engine ever built.

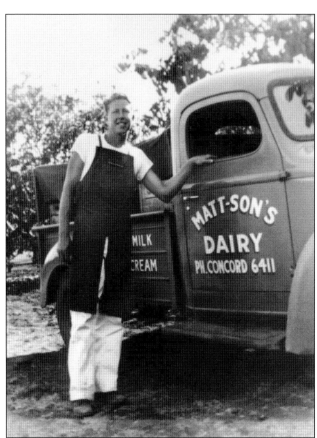

Ernrid G. Mattson arrived in Concord from Sweden in 1912. He married Bertha Johnson and had five children: Fred Jr., Robert, Kenneth, Norman, and Marjorie. The Mattson family established Matt-Son's Dairy in the 1930s. Matt-Son's Dairy delivered milk locally. Robert Mattson was one of the delivery men and is shown here in 1941.

The Mattsons expanded the dairy by building Matt-Son's Creamery on Willow Pass Road, which bottled milk and made ice cream and was later expanded to include a fountain and offer lunch.

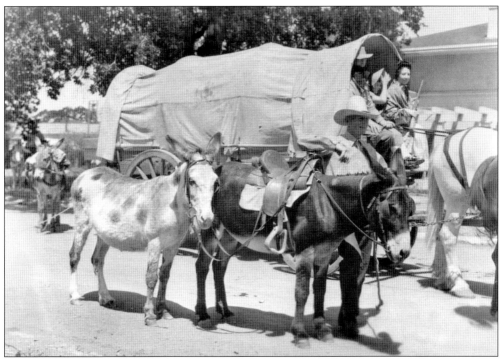

The Mattsons' wagon is used for the Odd Fellows–sponsored float in the Covered Wagon Parade. In the wagon are Joseph Frank, Sigred Frank, and their daughter Marie Frank (Larson).

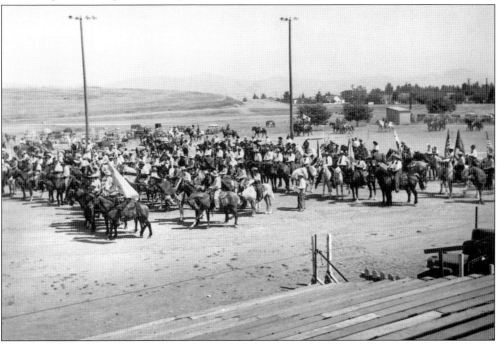

The Grand Entry Labor Day Horse Show was held at Concord Recreation Park in 1943. In the late 1950s, the park site became the new civic center, including city hall and the library, at the corner of Salvio Street and Parkside Avenue.

Lloyd Crenna stands to the left of Paul Kittle in 1944. The Kittles lived across the street from the Crennas facing Galindo Street in the old Todd home. The Crennas lived in the old Kelly house at Bonifacio and Galindo Streets.

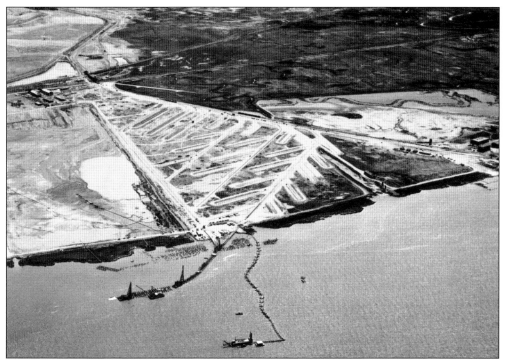

The naval magazine at Port Chicago was established by the U.S. Navy on December 4, 1942. Port Chicago was the navy's largest ammunition shipping point on the West Coast.

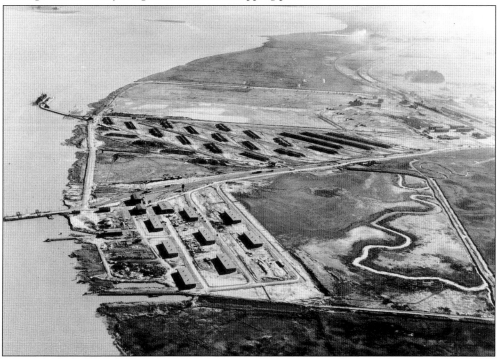

The naval base at Port Chicago employed about 2,200 military personnel and about 1,800 civilians. The pier on the center left above was the location of the Port Chicago Explosion of 1944.

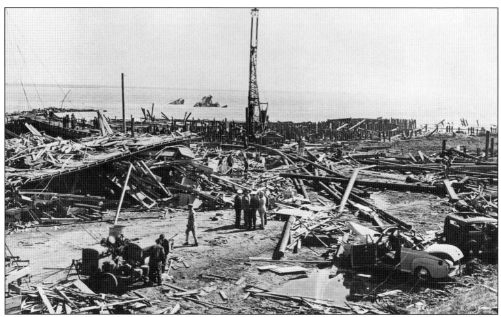

On the night of July 17, 1944, a brilliant flash lit the sky as two ammunition ships at Port Chicago, the *E. A. Bryan* and the *Quinalt Victory*, exploded. The blast from a reported 3,500 tons of explosives rocked the area for miles, breaking glass out of windows, cracking walls, and dropping chimneys. The aftermath of the explosion and destroyed pier is show in this classified photograph released by the U.S. Navy in 1992.

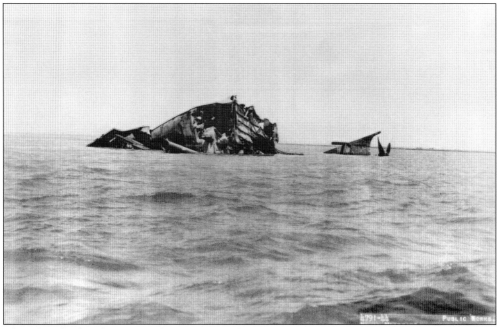

Three hundred and twenty military personnel died in the explosions, and another 390 military and civilians were injured. The pier where ammunition was being transferred from railcars to the ship *E. A. Bryan* was badly damaged. Five days after the blast, the remains of the *Quinalt Victory*, shown here, lay in shallow water off Port Chicago.

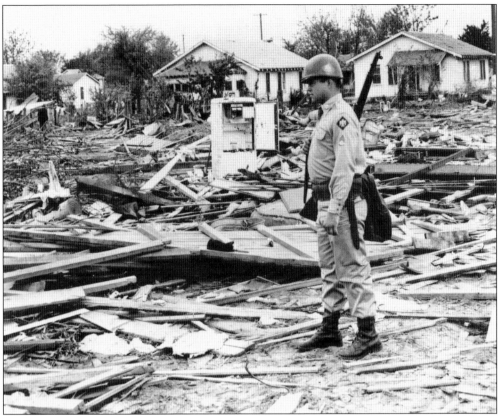

An army soldier guards the destroyed area of the Port Chicago Naval Weapons Station after the explosion. This photograph was also released by the U.S. Navy in 1992.

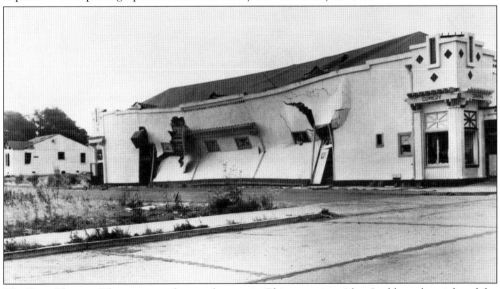

The Port Chicago Theatre was playing the movie *China* starring Alan Ladd on the night of the explosion. Plaster fell from the ceiling, and one wall of the theater collapsed. Local resident Janice McKinnon escaped the theater with other moviegoers.

www.arcadiapublishing.com

MAP SEARCH

Discover books about the town where you grew up, the cities where your friends and families live, the town where your parents met, or even that retirement spot you've been dreaming about. Our Web site provides history lovers with exclusive deals, advanced notification about new titles, e-mail alerts of author events, and much more.

MADE IN THE

Arcadia Publishing, the leading local history publisher in the United States, is committed to making history accessible and meaningful through publishing books that celebrate and preserve the heritage of America's people and places. Consistent with our mission to preserve history on a local level, this book was printed in South Carolina on American-made paper and manufactured entirely in the United States.

This book carries the accredited Forest Stewardship Council (FSC) label and is printed on 100 percent FSC-certified paper. Products carrying the FSC label are independently certified to assure consumers that they come from forests that are managed to meet the social, economic, and ecological needs of present and future generations.

FSC
Mixed Sources
Product group from well-managed forests and other controlled sources

Cert no. SW-COC-001530
www.fsc.org
© 1996 Forest Stewardship Council

Find Your Place in History.